# HISPANIC & LATINO
# HERITAGE
# *in* VIRGINIA

## • CHRISTINE STODDARD •

THE
History
PRESS

Published by The History Press
Charleston, SC
www.historypress.net

First published 2016

Manufactured in the United States

ISBN 978.1.62619.902.6

Library of Congress Control Number: 2016930872

*Notice*: The information in this book is true and complete to the best of our knowledge. It is offered without guarantee on the part of the author or The History Press. The author and The History Press disclaim all liability in connection with the use of this book.

*For my husband, David Fuchs; my parents, Mark and Lidia Cristina Stoddard; and the* Arlington Catholic Herald *staff.*

# CONTENTS

# ACKNOWLEDGEMENTS

This book would not have been possible without the Puffin Foundation in New Jersey. This national organization dedicated to empowering underrepresented voices awarded me a 2012 emerging artist grant to complete Mixteco/RVA, a photography-essay project on linguistic injustice in Virginia. That project inspired me to write this book.

I also am indebted to Michael Flach and Ann Augherton, editors at the *Arlington Catholic Herald*; Patricia Michelsen-King at Virginia Commonwealth University's School of World Studies; Spencer Turner and Eva Rocha at the now-defunct Virginia Center for Latin American Art; Jeff South at Virginia Commonwealth University's School of Mass Communications; Zack Budryk, a writer, journalist and former Virginia Commonwealth University classmate; writer and author Lisa Antonelli Bacon; the staff at the Wayside Center for Popular Education; Deveron Timberlake at *Belle* magazine and *Style Weekly*; Jenny Hollander, senior news editor at Bustle. com; Alanna Nuñez, who first discovered my writing as *Cosmo for Latinas'* web editor; Mark Oppenheimer, my mentor at Yale University's THREAD storytelling seminar; and last but not least, Marilyn Barrueta, a longtime Spanish teacher in Arlington County Public Schools who passed away in 2010. Thank you to all of you for helping me realize yet another dream.

# INTRODUCTION

*Then, I used to*
*walk on the banks of the goldening river every evening,*
*thinking you were dead long before I was born,*
*or maybe, that like the moss fed on dusk's damp moisture,*
*so wrapped around the appletree*
*you'd suddenly appear in the summer of my death.*
*I looked for your red and blue dress on every pavement.*
*Later, we discussing*
*the value of old remains at the bottom of dustbins*
*and the advantages of long journeys.*
*—"Then (Orduan)," by Bernardo Atxaga,*
*translated from Basque by Amaia Gabantxo*

A fried egg—greasy yet chalky—on rice and beans stared back at me from the foggy Tupperware container. My American father called arroz con huevo frito, one of my Salvadoran mother's specialties, "comfort food." Lizzie, my first grade classmate, scrunched up her nose and called it "disgusting" before she went back to nursing her Capri Sun. I sighed and walked my meal straight to the trash can, feeling the eyes of all the other six- and seven-year-olds on my back as I scraped every last grain into the garbage. Then I sulked back to the cafeteria table. On my left, one kid meticulously stacked her Lunchables sandwiches and talked about the Power Rangers. On my right, another kid ate a PB&J. My only friend in the class, the girl who usually rolled a grape or Gusher my way on such occasions, was absent that day. I

would not eat until after school, when I went home, where my mother had more rice and beans waiting. There, I could gobble them up freely.

It was the mid-'90s in Arlington, Virginia, a suburb of Washington, DC. My family lived in North Arlington, which was predominantly white and overall more affluent than South Arlington. My younger sisters and I were the only students at our public elementary school with a Latina mother; the few other immigrant mothers were educated Western European women with government jobs. When I reached fifth grade, a Puerto Rican family and a Chilean family moved into the neighborhood. But by then, my sisters and I had fine-tuned our defense mechanisms. We hid our lunches, threw them away or ate them quickly in the bathroom. We sought protection as teacher's pets and tattletales. And for the most part, if we heard, "Who's that Mexican lady? Is that your nanny?" at after-school dismissal, we didn't say anything. We piled into our mother's van, eager to get home to *Muzzy in Gondoland* and Spanish-language Disney movies or drive fifteen minutes away to play in Ballston, a North Arlington neighborhood close to the South Arlington border. At that time, Ballston was full of working-class immigrants.

I remember rolling out of our Ford E-series to survey our makeshift Mars. Developers had torn up the fields, transforming the land into a series of muddy hills and ravines. Spring showers pushed rain water through the gullies like artificial streams. Everything smelled of earth and sparkled with mica. Somewhere, my mother promised, if we looked hard enough, we would find something. Over the roar of cars rushing past Washington-Lee High School—the famed alma mater of stars like Shirley MacLaine, Warren Beatty and Sandra Bullock—a Nepalese girl three years my senior cried out something. Fuzzy in the distance, she resembled a subject from a Fauvist's frenzied painting until she stepped into focus.

"Hi, I'm Meena," the girl said. My first grade self immediately noticed her gold nose piercing shining even in the dull spring light. She wore a Biscayne blue top and bell-bottom jeans. My sisters and I bobbed out from behind our mother like quails, shyly waving hello. We instinctively liked Meena because we knew that she, like us, knew what it was like to be different.

"Hi, I'm Mrs. Stoddard," my mother said in her charming Central American accent. "Do you want to walk with us?"

That was the friendship that launched one thousand others, virtually all with fellow children of immigrants. Today, Meena is a doctor who studied in Copenhagen. We remain in touch—as many childhood friends do—on Facebook.

In those days, my mother was the mayor of Quincy Park. Anything-goes soccer and homemade lemonade became her trademarks. When she pulled into the gravel lot and stepped out of the family van, children jumped off the slides and out of trees, shouting, "Mrs. Stoddard! Mrs. Stoddard!" They bounded toward my sisters and me, but only because we served as moons to the main attraction: Planet Mommy. You first came to Mrs. Stoddard for soccer and refreshments. But soon you, like the many before you, would come to her for advice and jokes, whether in English or Spanish. Above all, you came to her for compassion.

My parents insisted that my sisters and I befriend a diverse mix of children, ones of different cultural and socioeconomic backgrounds. Of course, my parents didn't phrase it that way when we were little. Instead, around 4:30 p.m. every day, my mother would mix some bug juice in the kitchen, pack a cooler and say, "Let's go to the park."

From there, it was understood that we would help our mother load the car and then have her drive us to Quincy, about fifteen minutes away. Why not walk down the street? Because the perfectly manicured parks by our house were filled with our classmates. And by repeatedly playing with the junior members of the Washington Golf & Country Club, we could learn only that there was one type of person in the world.

Yet going to Quincy didn't change who my classmates were or who my mother was or even much how I behaved in school. As a chubby kid with a stutter, I hoped that my silence at Jamestown Elementary meant I could pass off my mother as my nanny for as long as possible. My loud, petite, olive-toned mother was not like the other mothers—blond, thin, Protestant—and therein lay my shame. Rather than feeling compassion for my mother, who fled El Salvador's horrific civil war and felt isolated in a strange place, I knew only embarrassment and confusion. I couldn't understand then why she wanted to put our house on the market and move back to Miami, where she lived shortly after leaving Central America. I was the entitled immigrant's daughter, privileged with an American accent and even lighter skin than what she, as a light-skinned mestiza, had. I preferred U2 and N'Sync over Cumbia and placed senior prom far above the quinceañera I refused to have.

In the summer of 2014, I moved to Falls Church, a town bordering Arlington. After sweating through the walk from my apartment, I reunited with my second grade teacher at a nearby Starbucks. We had not seen each other since I was eleven years old and bespeckled with fluffy bangs. When I bolted up from my chair to hug him, I tripped over someone's laptop cable. We laughed and hugged anyway, both tearing up.

My former teacher and now friend is gay, white and raising his adopted black children with his life partner in Northwest Washington, DC. As a little girl, I could not have understood his discomfort at teaching at my school—a place where teachers and parents alike espoused liberal values but still harbored the stereotypes and grandiosity that come with the dual privilege of being white and well-heeled.

Somewhere in our conversation, while I sipped on ice coffee, my friend examined my face and said, "It must have been so hard for your mother."

I shivered, and not because of the ice or the air-conditioning on full blast. I shivered because he was the first adult from that community to have ever acknowledged my mother's struggle to fit in. I also knew that he, too, had struggled.

"Do you know what your mother told me once at a parent-teacher conference?" my friend asked. "She told me that the other mothers thought she was your nanny."

At Quincy, the other parents saw past my mother's accent because most of them had accents of their own. They lived in apartment buildings, in some cases ones they could barely afford, forcing them to eventually move farther and farther from Washington. They had fled wars and the breed of poverty you encounter only in developing countries.

"Angloparlante." This Spanish word captures the social privilege I have known since I learned to speak. I can pronounce all twenty Standard American English vowel sounds with the slight drop of my jaw, the pursing of my lips. English is my native language. It is not my mother's. Yet she is completely fluent in this tongue she first heard in rock songs on the radio as a girl in El Salvador, making her one of the lucky ones. Light skinned, an English speaker and snubbed as a nanny anyway.

In 2010, I studied with my sister in Glasgow, Scotland, where class seemed unmistakeably linked to one's ability to mimic the Queen's English. I also noted, perhaps with some bitterness, a leftover resentment lingering from my adolescence that the Spaniards I overheard in the Glaswegian streets and cafés did not speak the same Spanish as my mother. Would the other mothers have treated her any differently if she had been a Spanish immigrant? A European? Yes. Of course. Because then, in their minds, she would have been white and more like them.

Before I continue, let me define two terms, going by Merriam Webster. The word "Hispanic" refers to anyone who can trace his or her origins to the Iberian Peninsula, where Spain and Portugal are located, though not all Portuguese embrace the term. "Latino" means anyone from Latin America

or anyone descended from Latin Americans. Neither word refers to race; rather, they refer to ethnicity. Being Hispanic does not make you "brown." Being Latino does not make you brown. But having more American Indian or African blood, perhaps, makes you appear, well, brown. As a Spanish-speaking person born in Central America, my mother is both Hispanic and Latina. Her old Miami driver's license identified her as a "White Hispanic." My old classmates and their mothers never would have considered her white.

Today, the Virginia I knew as a child is disappearing, neighborhood by neighborhood, and becoming increasingly multicultural, particularly Latino. When I first saw the new businesses and the increase in Spanish signage, I got excited. Then I felt guilty. Then curious. The feelings continue to rotate in a cycle with every sighting of a new pupusería and bodega. How much of my mother's ostracism had I imagined? Was it more serious than I ever knew? Or did my mother worry about it less than I did? It's tempting to overanalyze the past. Often, that temptation lures me into rewriting my memories, and I know I'm not the only one. Research can help stave off such vanity and allow us to decontextualize our pasts. But it's often personal experience that initiates the need for reading and field research to confirm or deny our suspicions. And here I am—still researching, still unsure, still hopeful, still scared. Hence this book.

This is the story of Hispanic and Latino heritage in Virginia—at least the beginning of it. ¡Viva Virginia!

# EARLY SPANISH EXPLORERS IN VIRGINIA

*From the standpoint of European history, the story of early colonial Virginia is the story of the intrusion of an alien group of English men and women—totaling some 200 in 1609 and 843 in 1621—into an Iberian Atlantic world.*
—*J.H. Elliott,* The Atlantic World and Virginia

**W**hen most modern Americans think of the first contact between Europeans and Virginia's indigenous people, they picture English ships sailing across the Atlantic toward uncharted territory. Thanks to Disney, they imagine Pocahontas standing on a cliff, hair billowing in the wind, as she serenades a smitten Captain John Smith. Another common reference point is Colonial Williamsburg, which in 2013 alone garnered an estimated 1.8 million visitors. Maybe they remember a family vacation to Colonial Williamsburg, where everyone put on tricorn hats, visited a few tradesmen, took rides in a horse-drawn carriage and completed the experience with dinner at a faux eighteenth-century tavern.

Theories abound that perhaps the Spanish flirted with settling Virginia well before the birth of Jamestown. The tale that opened the door to such a legacy was that of the Spanish conquistadores who notoriously stumbled into America instead of their desired India. After Christopher Columbus and his men descended on the island of Hispaniola, the so-called Age of Discovery began, and Spain was doing much of the so-called discovering. Before the English named Virginia after their virgin queen, Elizabeth I, modern-day Virginia belonged to the large region the Spanish called Ajacán.

Christopher Columbus and his men reached Hispaniola in 1492, thus initiating Spanish influence in the Americas. The Spanish first arrived in Virginia in the 1560s. *Library of Congress.*

Virginia's first Thanksgiving occurred in 1619 at Berkeley Plantation (pictured here). But Spanish settlers celebrated their first Thanksgiving in St. Augustine in 1565. *Christine Stoddard.*

Revolutionary War reenactors visit Holy Family Catholic School for a presentation on the English colonial era, which began after the Spanish allegedly had already reached Virginia. *Christine Stoddard.*

Whether the Spaniards actually arrived in the Virginia portion of Ajacán remains unconfirmed. As noted on EncyclopediaVirginia.org, a publication of the Virginia Foundation of the Humanities, Spanish explorer Lucas Vásquez de Ayllón and his men likely exaggerated when they told the king that they made it as far north as the Chesapeake Bay in 1526. If they were telling the truth, however, their settlement, San Miguel de Guandalpe (not to be confused with the better-known Spanish word "Guadalupe"), preceded Jamestown by eight decades. It lasted all of three months, and its location remains unknown even today. That said, contemporary scholars more commonly place San Miguel de Guandalpe in Georgia or the Carolinas. Whether you search for "Lucas Vásquez de Ayllón" in Encyclopedia Britannica, Encyclopedia.com or any number of other encyclopedias, you'll notice scant mention of Virginia, if any at all.

Another conjecture of early Hispanic contact in Virginia points to a group of missionaries. Matthew M. Anger's colorful 2003 article for *Seattle Catholic* tells the story of the Santa María de Ajacán Mission, which was established in eastern Virginia in 1570. According to a servant boy's account, the mission failed when an Algonquin convert named Don Luís betrayed the Spanish missionaries he was guiding and had them killed. The Jesuits' servant, Alonso de Olmos, escaped and later bore testament when a Spanish

Since Spanish explorers never permanently settled in Virginia, they left no architectural evidence. Contrast that to El Morro, a castle in San Juan, Puerto Rico. *Christine Stoddard*.

The Spanish built castles like El Morro to protect their territories from competing powers. But Virginia was never a Spanish territory. Hence, there is no Spanish castle. *Christine Stoddard*.

Spanish Colonial architecture may abound in St. Augustine and San Juan, but do not mistake Virginia's lack of it for a lack of Hispanic heritage. *Christine Stoddard*.

Virginia also lacks a Spanish colonial cemetery, such as this Santa María Magdalena de Pazzis Cemetery in San Juan, Puerto Rico. *Christine Stoddard*.

relief expedition found him a couple years later. After this massacre, Spain ended its attempts to colonize modern-day Virginia and concentrated on settling American soil farther south.

In 2002, the Catholic Diocese of Richmond initiated the process to have the missionaries canonized, which Anger writes "has renewed interest in the fascinating, almost fantastic, tale of a lost Spanish colony in Virginia." In 2013, the cause moved to the Congregation for Saints' Causes at the Vatican.

If the Spanish never quite made it to modern-day Virginia before the English, then they probably came close. One of the more popular origin stories of the famous wild ponies roaming Chincoteague National Wildlife Refuge is that their ancestors escaped a shipwrecked Spanish galleon in the 1500s. But nobody knows for sure because ponies, let alone the ghosts of ponies, cannot talk.

# 2
# MODERN LATINO IMMIGRATION TO VIRGINIA

*The substantial demographic increase of Latinos in the 1980s and 1990s transformed the DC area to a place where the Spanish language is common and the people and culture of the Iberian diaspora form a prominent part of the area's identity. Latinos work and are successful in all occupational positions and contribute to politics, education, and the areas.*
— *Maria Sprehn-Malagón, Jorge Hernandez-Fujigaki and Linda Robinson,*
Images of America: Latinos in the Washington Metro Area

Immigration to Virginia began when the English first anchored in the Chesapeake. Considering that the Paleo-Indians came over the land bridge connecting Asia to North America an estimated fifteen thousand years ago, by the time Jamestown was settled, the first people of Virginia had already inhabited the land for generations. From that point onward, all manner of European immigrants eventually settled in Virginia—with Spaniards among them—though the colony was best known for its English, Scotch-Irish and German settlers.

Prior to 1980, when the US census first began including the term "Hispanic," many Hispanic and Latino immigrants identified as white, even if they were not purely of Spanish origin. Thus, it is difficult to estimate Virginia's Hispanic and Latino population before that point. If it is not safe to cite exact numbers, it is safe to say that Northern Virginia, where the state's largest Hispanic and Latino communities are still concentrated today, has seen three waves of Latino immigrants. The first wave consisted of

Cubans and Dominicans, who came in the 1950s and '60s. The second wave consisted of South Americans, who came in the 1960s and '70s. The biggest wave, perhaps better described as a tsunami, was led by Central Americans in the 1980s and early '90s.

Though Salvadorans currently are the most prevalent of the state's Latino groups, they do not form the majority of its Latino population. According to the Migration Policy Institute's tabulations of 2013 US census numbers, Central Americans made up 23.7 percent of Virginia's immigrants across nationalities. Of this group, 10.2 percent of Virginia's Central American immigrants are Salvadoran, 6.8 percent are Mexican and 6.6 percent are other Central American nationalities. South Americans made up 9.1 percent of Virginia's immigrant population. Caribbeans made up 3.3 percent. Cubans specifically made up 0.7 percent. What the Washington, DC metro area can claim is the largest Bolivian community in the country.

According to the Pew Research Center, Virginia has one of the highest concentrations of Salvadoran immigrants in the country. Of the estimated two million Salvadoran and Salvadoran American immigrants living in the United States, 7 percent live in Virginia. California and Texas also have sizable Salvadoran communities. The Migration Policy Institute cites Salvadorans as the sixth-largest immigrant group in the country, preceded only by Mexicans, Filipinos, Indians, Chinese and Vietnamese communities.

Each immigrant group left its homeland for a complex set of political and socioeconomic reasons. Take the Salvadorans. Many Salvadorans fled to the state because they sought refuge from El Salvador's civil war (1979–92) and ensuing gang epidemic. Poverty and natural disasters also have contributed to the Salvadoran influx, though these factors have been worsened by the scars left by the country's long and bloody conflict.

To get some sense of the challenges Salvadorans faced during and since the civil war, put yourself in 1980, when Bishop Óscar Romero was assassinated while celebrating Mass in a hospital chapel in the capital of San Salvador. The assassination aggravated tensions between the country's extremely rich minority and extremely poor majority. Romero championed liberation theology—the philosophy that the faithful should recognize and ameliorate social injustices as Christ did—and famously stood up for the poor and oppressed. This included opposing US military aid to the Salvadoran government during the civil war.

Father Zacarias Martínez, parochial vicar at Good Shepherd Church in Alexandria, visited San Salvador for Romero's beatification in May

Political strife and natural disasters have caused many Salvadorans to seek refuge in Northern Virginia. This 1917 photo depicts a volcanic eruption in San Salvador. *Library of Congress.*

2015. The beatification took place at an outdoor Mass held in Plaza Divino Salvador del Mundo. Italian cardinal Angelo Amato, prefect of the Congregation for Saints' Causes, celebrated the Mass.

"In the [best] sense of the word, we [Salvadorans] should feel proud to have a beatified bishop, pastor and prophet," said Father Martínez. "For the many of us Salvadorans living in Virginia, this should be a sign from God, a hopeful sign that today beatification and sainthood are upon us. We should take Monsignor Romero's example of humility, sensitivity, being a man of prayer, loyal to the Word of God, a man of hope and a burning candle for the Eucharist."

Efforts for the bishop's beatification and canonization began in the early 1990s, with the Congregation for Saints' Causes accepting documents in 1997 under Pope John Paul II, but controversy has long shrouded canonization efforts for the bishop, as a miracle is generally required for sainthood. Pope Francis has sped up the canonization process for Bishop Romero, declaring him a martyr in February 2015.

Today in Northern Virginia, there are several Salvadoran enclaves in Arlington, Alexandria, Woodbridge and Manassas. Ballston and South

Virginia's Salvadoran population is concentrated in the national capital region outside Washington. This photo (circa 1909) depicts the National Palace of El Salvador. *Library of Congress.*

Arlington are losing much of the Salvadoran community that developed there in the 1980s and '90s due to Arlington County's rising housing prices. According to the major real estate website Zillow.com, the median sale price for an Arlington home was $526,400, or $431 per square foot, in 2015. Arlington's more popular neighborhoods have even higher going rates. The median Zillow Home Value Index for Lyon Village is $1,163,600; it's $914,100 for Ashton Heights and $851,200 for Cherrydale. RentJungle. com lists the average December 2015 rent for a one-bedroom apartment in Arlington as $1,806 and $2,229 for a two-bedroom. Inside the Beltway, Chirilagua in the city of Alexandria, a neighborhood just north of Del Ray, still maintains a healthy Salvadoran community. Otherwise, the trend is toward moving farther west of Washington, DC, as the metro area becomes increasingly expensive. Hence the growing popularity of places like Manassas and Woodbridge in Prince William County.

Outside Northern Virginia, Salvadorans and other Latino immigrants are spottier, though they still exist. In the Richmond metro area, Latino immigrants cluster in the city's Southside and nearby Chesterfield County. Harrisonburg, Charlottesville, Virginia Beach and Winchester also have noticeable Latino communities.

Immigration has long been an American concern, with different groups settling in waves since the country's inception. The case with Latino immigrants is no different. But as in previous generations, not everyone welcomes immigrants. Some Virginians view immigrants as criminals or "job stealers." Others have racist objections. One of the most recent outcries has been against the wave of tens of thousands of undocumented Central American children who came to the United States in 2014. Many of the children traveled without their parents to escape escalated violence and

*Above*: The city of Alexandria boasts a prominent Latino community. This archival photo depicts Alexandria Market House and City Hall at 301 King Street. *Library of Congress.*

*Right*: This 1863 photo depicts the historic Fairfax County Courthouse. According to the 2014 US census, Fairfax is home to more than 180,000 Hispanics. *Fairfax Library of Congress.*

poverty in Guatemala, Honduras and El Salvador. Though the surge of undocumented children dropped in 2015, Virginia, like many states across the country, is still working to address this crisis of minors in need of food, shelter and education.

Virginia also is home to a sizable number of Central American immigrants who are separated from their children and want to bring them to the United

This archival photo depicts the Dranesville Tavern in Herndon. US census numbers show that Hispanics make up about one-third of Herndon's population. *Library of Congress.*

Manassas recently has witnessed a spike in its Latino population. This archival photo (circa 1861) depicts the Battlefield of Bull Run, a prominent local landmark. *Library of Congress.*

*Opposite, bottom*: Arlington's Glebe Road corridor from Ballston to the Alexandria border boasts a rich Latino community. *Library of Congress.*

States, not only out of love, but also out of fear for their safety. Such was the plight of the seventeen parents who gathered at a Catholic Charities office in Arlington on the morning of July 8, 2015, to complete paperwork for the Central American Minors (CAM) refugee/parole program, a federal program that began accepting applications in December 2014. With the guidance of the diocesan Catholic Charities Migration and Refugee Services (MRS), they were taking the first step toward petitioning for their sons and daughters to come to the United States under refugee status.

Though no dreams were fulfilled that morning, at least one was broken. One woman, whose son was approaching his twenty-second birthday and was just now attempting to file the necessary paperwork, discovered that she was already a year too late. She left the orientation crying.

Managed by US Citizenship and Immigration Services, CAM states a few firm requirements: Parents who petition for their children must be in the United States legally; the children must reside in El Salvador, Guatemala or Honduras and be nationals of those countries; and the children must be under the age of twenty-one at the time the paperwork is filed. Though the children must be unmarried, if they have sons and daughters of their own, if found eligible, their children may come with them. But the firmest requirement is that the children must be refugees. US Citizenship and Immigration Services defines refugees as those "who have been persecuted or fear they will be persecuted on account of race, religion, nationality and/or membership in a particular social group or political opinion."

The US government performs DNA testing on each candidate to ensure the parent and child are biologically related. Sometimes fathers discover that children they raised as their own are not their children, said Beth Fitzpatrick, Catholic Charities MRS volunteer program coordinator.

While there is no deadline for filing for the program, it benefits parents to file earlier rather than later. As of July 2014, no applications that have gone through the diocesan MRS office have been approved.

Catholic Charities is not the only Virginia group seeking to address the issue of unaccompanied minors and other immigration matters. Over the past several years, many Virginia jurisdictions and universities have developed offices specifically tasked with helping immigrants navigate new territory. The words "multicultural," "immigration," "Latino" and "Hispanic" are usually in the office's name. The City of Richmond has the Office of Multicultural Affairs, previously known as the Hispanic Liaison Office, while Fairfax County's Seven Corners area has the Willston Multicultural Center. AmeriCorps, the domestic version of the Peace Corps, sometimes partners with nonprofits in need of part-time or full-time volunteers to assist immigrants. Then, of course, immigration law firms such as Fayad Law, Livesay & Myers, Pride Immigration Law Firm and Poarch Law Firm make a business out of handling immigration troubles.

As with other immigrant groups before them, Hispanics and Latinos likely will gradually gain wider acceptance in Virginia and become fully integrated into their communities. Until then, new immigrants will continue dancing the delicate dance of assimilation, as they and society decide which aspects of their culture to keep and which to lose.

# 3
# TRADITIONS AND FOLK LIFE IN VIRGINIA

*Laughter is heard, and his*
*invisible arm points out*
*the solemn statues of heroes. If*
*someone pronounces the word*
*"liberty" a kind of lightheadedness,*
*as if from wine or maybe*
*from extreme youth, clouds*
*his pathetic nonexistence.*
*—From "Ballad for an Invisible Man," Rafael Guillén,*
*translated from the Spanish by Sandy McKinney*

Hispanic and Latino immigrants have been adapting their traditions to Virginia for as long as they have been coming to the state and settling in their new home. The difference between the past and more recent years is that these traditions are becoming more widely visible in Northern Virginia and have even trickled to towns farther south as the immigrant population continues to grow.

Though immigration often fractures families in the worst circumstances, family, or familia, is still central to Hispanic and Latino cultures. Immigrants often must make a special effort to gather to observe holidays and major traditions. Even for those immigrants permanently separated from their families, public celebrations must be a welcome respite from the daily grind of an alien, and sometimes antagonistic, culture.

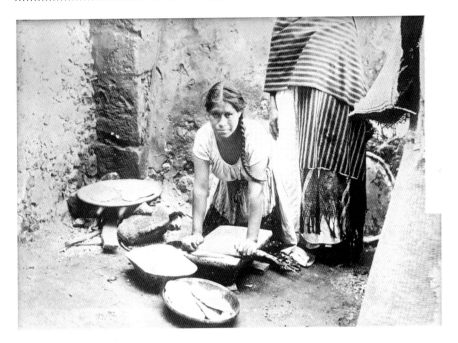

This archival image (circa 1908–19) depicts a Mexican woman at work. Today, many—but by no means all—Latin Americans live a traditional agrarian lifestyle. *Library of Congress.*

Cinco de Mayo is a Mexican holiday that has gained favor in the United States, becoming an even bigger deal here than in its home country. Though commonly confused with Mexican Independence Day, Cinco de Mayo is a celebration of Mexican forces beating out the French in the Battle of Puebla on May 5, 1862. Cinco de Mayo festivals are fast becoming crowd pleasers that unite Mexican and non-Mexican groups alike from across a locale. Every year, the Virginia Hispanic Chamber of Commerce hosts the ¿Qué Pasa? Cinco de Mayo Festival in Richmond. Thousands flock to the city's canal to see Incan designs, Venezuelan artistry, Bolivian dancers and other attractions that are Hispanic or Latino but not Mexican. Immigration blurs homeland traditions and creates new ones in the process.

Two other notable examples of Hispanic and Latino cultural blends you will find in Virginia are food and music. Restaurants often are not exclusively Mexican or Salvadoran but both. Pupusas, once a rarity in Northern Virginia's culinary scene, are now ubiquitous and offered on the same menu as Mexican enchiladas and tacos al pastor. Virginia dance schools usually do not teach dances traditional to a single country but

Music is central to all Latin American cultures, though musical interpretations and dances vary widely from country to country. *Christine Stoddard.*

Mexican and Salvadoran street food includes a spectrum of treats now popular in food trucks throughout Northern Virginia. *Christine Stoddard.*

*Left*: Popular Mexican and Salvadoran beverages include michelada, sangria, tamarindo, agua fresca, horchata, champurrado and many others. They are becoming increasingly common in Virginia's restaurants and grocery stores. *Helen Stoddard.*

*Right*: With the rise of Virginia's Latino population, tropical fruits and other produce popular in Latin America are becoming easier to find in local grocery stores. *Helen Stoddard.*

lump "Latin dances" together in the same club or course. Learn bachata the same month as tango. Catholic churches do not have separate Masses to observe Mexican or Bolivian liturgical traditions. Instead, they usually offer a single Spanish-language Mass and honor different traditions if and when time and resources allow.

As Hispanic and Latino traditions become more visible in Virginia, people from outside of these cultures have the chance to learn more about these practices. Yet misconceptions still exist. Here are a few examples of traditional folk life manifested in Virginia with more and more prominence but whose nuances are not always understood.

## QUINCEAÑERAS

"Abandon the notion that girls become women at age fifteen," said Father Alexander Díaz at a 2015 diocesan retreat for Hispanic girls. "[That milestone birthday] is the first step toward womanhood, but fifteen-year-old girls are still girls."

Father Díaz, who serves as parochial vicar at Holy Family Church in Dale City, was addressing a room full of parents and their fourteen-year-old daughters at a diocesan retreat on February 21, 2015. The retreat was part of a new effort meant to prepare parents and girls for quinceañeras, the predominantly Mexican and Central American equivalent of a Sweet Sixteen.

Quinces, as they're known for short, originated in the New World during the Spanish colonial era as a coming-of-age ceremony. Back then, once a girl turned fifteen, she received a priest's blessing to either marry or enter the convent, thus becoming a woman in the eyes of society. Today, quince blessings are more likely to be followed by parties than betrothals. Some parties are as lavish as weddings, with catered food, live mariachi music, professional photographers and other luxuries. According to Father Díaz, the US minimum average cost for a quince is $10,000 but can reach upward of $25,000.

"Parents are spending what they don't have," he said. "They go into debt; they put the party on a credit card. They don't want to break their girls' hearts. But how many of them are thinking about college? What lesson is that for girls? I'm not against a party, but do it properly."

Organized by Karla Alemán, an administrative assistant for the Spanish Apostolate, Arlington's quince retreats take place on select Saturdays at the diocesan center on North Glebe Road. The program was designed to remind parents and girls of the milestone's spiritual aspect and give them context for how celebrating in Virginia may be different from celebrating in their home countries.

The first part of the retreat introduces the origin of the quinceañera and how the celebrations have evolved over time. The second part discusses quinces in terms of vocations, or discerning God's will and planning for one's future. The third part focuses on the Christian aspect of quinces and what it means to be a Catholic woman. The fourth part discusses quince etiquette in a church setting, with specific Northern Virginia parishes as examples. Girls are expected to participate in the retreat through discussion and light journaling. At the end of the program, the girls receive a certificate of completion and a fresh rose.

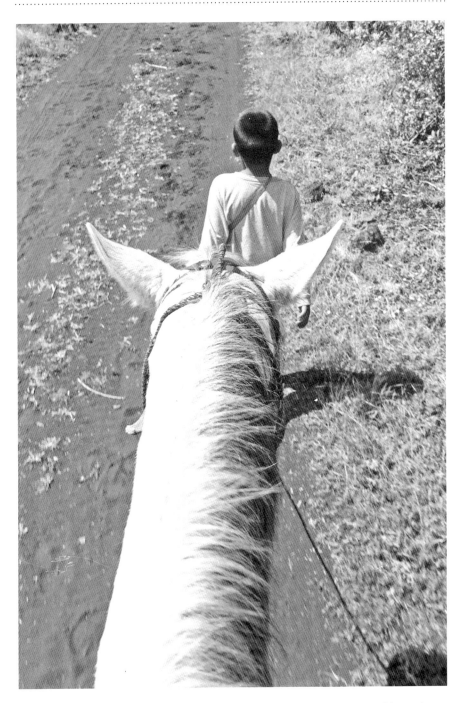

Latino immigrants coming from an agrarian background often must abandon tradition and learn new skills in order to thrive in Virginia's urban and suburban environments. *Helen Stoddard.*

Throughout the morning, Father Díaz emphasized the importance of education and hard work for any girl. He told parents to treat their daughters the same as their sons and to be open-minded about their daughters' career goals. Families should prioritize college and Christian values over ostentatious quinces.

"An educated woman is like a precious diamond," he said. "An educated woman contributes to society."

Father Díaz asked girls to look at visionaries from throughout history—Gandhi, Salvadoran martyr Bishop Óscar Romero, Supreme Court justice Sonia Sotomayor—as role models and discouraged them from emulating pop stars.

Father Díaz said, "I don't know if I'm standing among the first female president, a future Supreme Court justice, the person who will discover the cure for cancer or a new planet in the universe. But I don't ask that you become presidents. I ask that you reach your full potential."

When Father Díaz asked the girls about their dream jobs, their answers ranged from doctor to astronomer to FBI agent to animator. He encouraged them to focus on those dreams while still making time for fun. That fun may include healthy outlets like sports or dancing but not drugs, premarital sex or other sinful activities that "break your friendship with God."

He warned parents against serving alcohol to minors at quinces, putting their daughters in revealing dresses and hiring indiscreet photographers who interrupt Mass. He also asked families to respect the Eucharist, observe the sacraments and remember that a quince is about their daughters' blessing and vocation.

"Fall in love with work," Father Díaz told the girls. "Work dignifies. People who work hard fly high."

# Día de los Muertos

How do you insult death? According to Mexican wisdom, by giving in to melancholy. While autumn conjures the somber and scary in Americans' imaginations, Mexicans picture the happy and bright. That's because el Día de los Muertos, or Day of the Dead, is upon us.

El Día de los Muertos, the Mexican interpretation of Allhallowtide, celebrates and good-naturedly mocks death as a means of accepting and

*Above*: A family built this Day of the Dead altar for their ancestors in Pátzcuaro, Mexico, which boasts elaborate Day of the Dead displays. *Helen Stoddard.*

*Left*: Sugar skulls are ubiquitous at Day of the Dead, or Día de los Muertos, celebrations. *Helen Stoddard.*

reducing fear of it. Legend has it that when November rolls around, the souls of the dead briefly return to visit their loved ones. Deceased children and infants (los angelitos, or little angels) arrive on November 1, and adults come on November 2. Celebrants honor the spirits with gifts, music and prayer. They visit graves to clean and decorate them with candles and marigolds (which symbolize death). Homemade altars adorned with the cross, images of the Virgin Mary, photos of the deceased and papel picado (perforated paper, a signature of Mexican folk art) are another common sight. Typically, people leave ofrendas, or offerings, for the spirits, which vary according to what the deceased person liked in life. Parades, vigils, dancing and feasting often take place near or at the cemetery. Traditional foods include mole, tamales, tortillas, fresh fruit, hot chocolate, sugar skulls and pan de muerto ("bread of the dead"). In exchange for all the joy and reverence, folklore holds that the spirits will protect their loved ones from evil.

Come fall, el Día de los Muertos permeates Mexican media and popular culture. Newspapers print Calaveras, seasonal poems that mock death with lines like "La muerte es flaca y no puede conmigo" ("Death is skinny and cannot carry me"). Cartoons and illustrations of skeleton archetypes such as la pelona ("Baldy"), la flaca ("the skinny one"), la huesada ("the bony one") and the character La Calavera Catrina, an elegant lady skeleton, also mock death. Performances of the play *Don Juan Tenorio*, a self-described religious fantasy drama by José Zorrilla, draw crowds to theaters.

Though the two-day celebration originated in Mexico, much of Central America now embraces el Día de los Muertos. The holiday fuses pre-Columbian traditions dating back at least two thousand years with the Catholicism brought by Spanish conquistadores. Today, the Mexican cities best known for their elaborate Día de los Muertos festivities are Oaxaca, Pátzcuaro, Huejutla, Chiapa de Corzo and Mixquic. Brazil celebrates a similar holiday called Dia de Finados, while Spain, the Philippines and Catholic Africa have their own takes on All Souls' and All Saints' Days.

El Día de los Muertos has started to gain wider recognition in the United States. Perhaps the most recent and notable example is 20th Century Fox's release of *The Book of Life*. The 2014 animated musical comedy centers on a group of schoolchildren whose trip to a museum helps them learn the mysteries of Mexican folklore.

Within the Arlington Diocese, St. Bernadette School in Springfield builds a Día de los Muertos altar and decorates a hall near the front

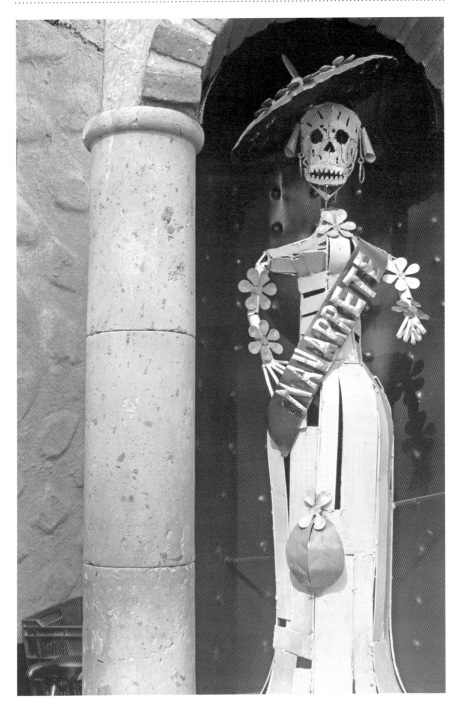

*Calaveras*, or skull and skeleton figures, are the primary subjects in Day of the Dead imagery. *Christine Stoddard.*

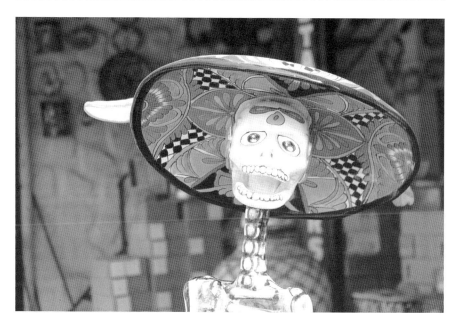

Day of the Dead imagery typically features skeletons with light-hearted expressions to commemorate death as peaceful, joyful and natural. *Christine Stoddard.*

office with folkloric art. Spanish and art students may make mobiles or miniature skeletons from plastic straws, among other crafts, depending on the year. Spanish teacher María Schlosser also encourages students to bring in photos of their deceased loved ones to place at the altar.

"[The students] learn to honor their ancestors in a happy way," said Schlosser. "It's good for them spiritually." Schlosser, who was born and raised in Guadalajara, Mexico, grew up celebrating el Día de los Muertos.

The Arlington Arts Center at Virginia Square has celebrated the holiday by producing an annual exhibit for more than a decade. The exhibit showcases the work of local artists and includes a reception with mariachi music, Mexican food and a children's art workshop.

David Amoroso, who has curated the show since its inception, said, "No matter what your beliefs may be, Day of the Dead is an opportunity to remember your loved ones. Hopefully we can all learn that our deceased loved ones will live on with us as long as we remember them."

## OUR LADY OF GUADALUPE

All of the tensions between races, religions and cultures that took place when the English settled in Virginia were in many ways a repeat of what had happened in Mexico nearly a century earlier. As invaders, the Spanish conquistadors did not receive a warm welcome from the indigenous people of Mexico. At first, the Aztecs rejected the Spanish ideas and customs forced on them, but the Spanish eventually won out in the culture clash.

Motecuhzoma, the ruler of Tenochtitlan, Mexico, during the first Mexican contact with Europeans, may have taken the Spanish for "gods" because of their white skin and facial hair, but he did not trust them.

In *Codex Florentino*, Benedictine priest Bernardino de Sahagún wrote:

> *Motecuhzoma* [sent his] *magicians to learn what sort of people the strangers might be, but they were also to see if they could work some charm against them, or do them some mischief. They might be able to direct a*

This restrike print created by the artist José Guadalupe Posada in 1900 depicts Our Lady of Guadalupe on an altar. *Library of Congress.*

*harmful wind against them, or cause them to break out in sores, or injure them in some way. Or they might be able to repeat some enchanted word, over and over, that would cause them to fall sick, or die, or return to their own land.*

In 1521, Hernán Cortés and his men conquered Mexico. Shortly thereafter, Franciscan missionaries arrived from Spain and began their evangelization efforts. Dominicans and Augustinians followed. The missionaries built hospitals, schools and other amenities as a means to convert the Mexicans, but one of the biggest influencers in indigenous conversion was an apparition witnessed by Juan Diego, an Aztec convert.

Legend has it that on December 9, 1531, Juan Diego was on his way to Mass when he heard a faint melody. Out of nowhere came a lovely lady calling his name. Speaking Nahuatl, the language of the Aztecs, she identified herself as the Virgin Mary and promised to help Juan Diego's people, but she also made a request: that Juan Diego go to the bishop, tell him of his vision and ask that a shrine be built in Mary's name. Juan Diego went to the bishop but was met with doubt. The bishop said he could not approve the construction of a shrine unless Juan Diego offered proof of his vision.

On December 12, Mary reappeared before Juan Diego and asked him to collect roses in his cloak. Juan Diego did as he was told and took the roses to the bishop. When he opened the cloak, the roses fell to the floor and revealed a picture of Mary printed on the cloth. She looked like an indigenous lady, not a Spanish one. The origin of the word "Guadalupe" remains unknown and may or may not be a transliteration of a Nahuatl word.

Today, the Guadalupe shrine claims to have Juan Diego's original cloak on display. La Villa de Guadalupe, a complex of two basilicas, three chapels, a cemetery and other religious sites, sits at the foot of Tepeyac Hill, three miles northeast of Mexico City. The old basilica opened its doors in 1709, while the new one, which houses Juan Diego's cloak, was completed in 1976. The complex is the most popular Marian shrine in the world and has attracted scores of pilgrims since the 1500s. It is estimated that twenty million people visit the shrine every year, with about half of them coming around December 12, the Virgin of Guadalupe's feast day. Many pilgrims arrive on the night before the feast day and camp out on a large plaza outside the basilica. They celebrate with prayer, music, street food and a marketplace full of Guadalupe memorabilia.

"There is so much at La Villa de Guadalupe," said Julia Young, assistant professor of history at the Catholic University in Washington,

DC, "that you could spend the whole feast day looking at things and still not see everything."

Any hour of the day and any time of year, the faithful around the world also may view live video streams on the new basilica's website.

While Mary has long been the patron saint of Mexico, the church proclaimed her the patroness of the Americas in 1999. Juan Diego was canonized in 2002, making him the first Amerindian Catholic saint. Today, Latinos—not only Mexicans—venerate Our Lady of Guadalupe. That includes many Latinos in Virginia.

"For our immigrant community, the Virgin of Guadalupe represents the wait, the hope and the motives to continue living and fighting in this world," wrote Father José Eugenio Hoyos, director of the Arlington Diocese's Spanish Apostolate. Father Hoyos was born and raised in Colombia.

Several churches in the diocese, including All Saints in Manassas and St. Matthew in Spotsylvania, celebrate Masses and hold fiestas in honor of Our Lady of Guadalupe every December.

Our Lady of Guadalupe even has a place in secular society, representing the hopes of the oppressed in a broader sense.

"As early as the seventeenth century, the Virgin of Guadalupe was being used as a symbol of Mexican identity, not just religious, but politically," Young said. "People wore her image on their banners going into war. Our Lady of Guadalupe's story represents a kind of fusion of indigenous and Spanish Christian culture. It is one of the oldest venerations in the Americas."

As a reminder of Our Lady of Guadalupe's eternal love, Father Hoyos recalled the words that she spoke to Juan Diego: "'Am I not here, I who have the honor of being your Holy Mother? Are you not standing in my shadow, under my protection? Am I not the source of your joy? Are you not at my bosom, in the crux of my arms? What greater joy might you seek?"

Outside of Virginia's Catholic churches, it is not uncommon to spot images of Our Lady of Guadalupe on bumper stickers, window stickers, T-shirts, jewelry and other everyday decorations and accessories.

## Las Posadas

There are many overlaps between Latin American Christmas traditions and American ones. However, las posadas is particularly distinctive to the United States' southern neighbors.

When the conquistadors arrived in Mexico five hundred years ago, they brought their Catholic traditions to celebrate Christmas, and they blended their customs with those of the Azetcs to create las posadas, now celebrated in Mexico, Guatemala and other parts of Central America. During this era, the Aztecs believed that the god Quetzalcóatl, a large, feathered serpent, came down from the heavens to visit them during the winter solstice. Merchants used to dress up a slave to play the role of Quetzalcóatl during festivities held throughout the city. The slave would go from place to place, singing, dancing and receiving offerings from children. This lasted nine days. On the last day, there were midnight ceremonies in the temples, with sacrifices, incense, music and more. The Aztecs also honored Huitzilopochtli, the god of war and the sun, but in a more solemn manner. December 24 and 25 were the most sacred of these celebrations—coincidentally, the holiest of Advent, too.

In Virginia today, one can celebrate las posadas at any number of parishes, including Good Shepherd Catholic Church in Alexandria.

## DÍA DE LOS REYES MAGOS

When the star of Bethlehem rose in the sky, three magi—Melchoir, Gaspar and Baltazar—mounted their camels and braved the desert for many miles to kneel before an infant who was believed to be more than an infant. According to legend, the wise astrologers were confident that only a king could inspire such a change in the heavens. Today, Christians celebrate the magi's visit as the Epiphany, the culmination of the Twelve Days of Christmas. In Hispanic communities, this day is cherished as el Día de los Reyes Magos, or Three Kings Day.

"Overall, the day marks the climax of the Christmas celebration. Most in the Hispanic community still regard January 6 as the Day of the Kings," said Father Paul Turner, a well-known liturgical author and pastor of St. Anthony Church, a predominantly Hispanic parish in the Diocese of Kansas City/St. Joseph, Missouri.

For many Latin American and Spanish children, el Día de los Reyes Magos holds as much excitement as Christmas does for other Christian children. It is the day they traditionally open their presents, in honor of the gifts the magi bestowed on Baby Jesus. Just as children all around the world write letters and postcards to Santa Claus, Hispanic and Latino children may write letters and postcards to the kings, all three or just their favorite

one. On the night of January 5, children place bits of hay in their shoes or in an empty shoebox as a nod to Christ's humble beginnings. Then they leave the shoes or box under their bed for the kings to fill with candy and small toys. Some children may leave food for the camels. Bigger presents may be placed under the Christmas tree.

While flan and tres leches are popular sugary indulgences, the holiday's culinary centerpiece is Rosca de Reyes, a sweet pastry shaped like a wreath and topped with figs, cherries or candied fruit. A trinket of Baby Jesus is always hidden somewhere in the cake. Whoever finds the figurine first is crowned "king" or "queen" for the day. Some families also hide a fava bean in the cake. Its discoverer must pay for the next year's cake or the next year's Día de los Reyes Magos party, depending on the rules.

In Washington, DC, the holiday is observed with a parade of magi reenactors and live animals at Gala Theatre in the Columbia Heights neighborhood. Every year, Gala Theatre's event attracts families from across Northern Virginia and Maryland as they bid farewell to the Christmas season.

# PUBLIC AND PRIVATE EDUCATION

*But I suffered this labor happily for my love of learning.*
*—Mexican nun Sister Juana Inés de la Cruz in*
*"Reply to Sor Filotea de la Cruz," 1691*

**N**ewly immigrated children may require an abundance of extra help and encouragement as they adjust to life in the United States. Since many children make their first foray into American culture at school, public schools in particular bear this burden.

Unlike states like California and Texas, which have had bilingual education and English as a Second Language programs in place for some time, Virginia is still learning how to accommodate its more recent rush of Latino, Asian and Middle Eastern students in its public and parochial schools.

Heritage schools, such as Escuela Boliva in Arlington, are weekend and evening community schools designed to help children and teenagers preserve their Hispanic and Latino heritage. Latino heritage schools may offer language classes, history classes, dance lessons, cooking lessons and other education meant to familiarize students with the culture of their heritage. If a school has a religious affiliation, there may be a religious component as well, whether that means pastor visits or Bible study.

Since heritage schools are extracurricular, they allow students to participate in their families' culture and the new American culture at the same time. This way, children develop fluency in both Spanish and English

and become familiar with traditions from both cultures without falling behind in their studies at their home school.

Meanwhile, public universities are also trying to accommodate immigrant students as they begin college, whether through course options or social activities, and private universities are working to attract some of the most talented international students, including ones from Spain and Latin America. In both public and private education, Spanish-language instruction for non-native speakers is outpacing French and German instruction.

According to a 2013 study by the Pew Research Center, Virginia, DC and Maryland have the highest share of college-educated Latinos out of any region in the United States.

Ballotpedia's entry on affirmative action in Virginia states that, as of March 2015, eight of Virginia's public universities reported factoring in race in admissions decisions. These schools include the College of William & Mary, James Madison University, Longwood University, the University of Mary Washington, the University of Virginia, the University of Virginia's College at Wise, the Virginia Military Institute and Virginia Tech.

That same Ballotpedia entry cites data from the National Center for Education Statistics that say that, as of December 2014, 6.37 percent of Virginia's postsecondary students are Hispanic. That is relative to 59.18 percent whites and 22.67 percent blacks.

The University of Virginia, which is one of the most selective colleges in the country, runs its affirmative action initiatives through the Office of Equal Opportunity Programs. Michelle Sawwan is the current program coordinator of Hispanic/Latino, Native American and Middle Eastern Student Services. Latino, Hispanic and Latin American Services are run out of the Office of the Dean of Students. The initiative connects interested students to a peer-mentoring program, student organizations (e.g., Latino Student Alliance, Fuego Dance Team, Society of Hispanic Professional Engineers, et cetera) and an annual celebration called La Gala. La Gala is an evening gala that brings together Hispanic and Latino alumni, as well as current and prospective students.

Several private Virginia colleges—such as Hampden-Sydney College, Averett University, Eastern Mennonite University and Emory and Henry College—which operate independent of the state, explicitly define themselves as affirmative action institutions or have public affirmative action plans.

Here are more specific accounts of how Virginia schools are changing to both honor and abet Hispanic and Latino heritage in the state.

## PUBLIC SCHOOLS

The fifth grade students joked and laughed as they sat at a low table built for children half their age. Their skin tones fell across the spectrum; their accents came from around the world. It was June 2013 at Pinchbeck Elementary School in Henrico County.

The five children—one girl and four boys—were all dressed in typical American kid clothing: T-shirts, jeans, cargo pants. None spoke English as a mother tongue, yet that was the language they used to communicate with one another.

"Hey, stop it!"

"No, you stop it!"

They had been through a day of standardized testing, but they didn't seem fazed as Shannon Donovan, Pinchbeck's English as a Second Language instructor, pulled up a miniature chair and began a lesson.

Donovan has her work cut out for her. It is her job to teach these children English as they learn about the culture in which they have found themselves. These are kids for whom everything about America seems foreign, from the American education system to the food they eat at the cafeteria.

"We have a lot of rice at home," said Dui Bui, who emigrated from Vietnam with his family in 2012. "Like, a lot of rice. All the time. Not like at school."

Then-eleven-year-old Dui Bui was making the adjustment to US schools with help from his teacher and classmates at Pinchbeck.

As of 2013, Henrico's schools serve more than three thousand English as a Second Language students from 103 different nations, speaking ninety-seven languages. According to the US census, 10.8 percent of Henrico citizens were born outside the United States; 5.1 percent of Henrico residents are of Hispanic or Latino origin, and 6.8 percent are of Asian origin. In the past forty years, Henrico's Hispanic and Asian populations have increased by triple-digit percentages.

This growth is not unique to Henrico. Over the past decade, the Hispanic immigrant population has nearly doubled across Virginia, while the Asian-immigrant population has risen by 68 percent.

As its non-English-speaking population increases, Henrico County Public Schools has raised its ESL budget from $259,713 in 2011–12 to $300,222 in 2013–14—an increase of 16 percent.

At this point, Donovan has taught ESL for seven years, four of them at Pinchbeck. She works with about 70 students at a school with a total student

population of 540. Most of her students come from Latin America, Iraq, Saudi Arabia, Egypt, Cambodia and Ethiopia.

Who they are and where they're from varies every year. "More come in every summer, all summer," Donovan explained. "I don't learn my student enrollment for the fall until the first day of school."

Donovan shares a classroom with a special education teacher. It is a colorful, multi-age space with a board and shelves to divide the ESL section from the special ed section. Donovan and her assistant, Sarah Rutledge, pull children from their homeroom classes for ESL instruction and give the children a guided full-immersion English experience. Because Donovan and Rutledge do not speak other languages, the children must communicate in English.

With 13.5 percent of Henrico households speaking a language other than English at home, Donovan and her colleagues across the county are working not only with their students but also with the students' families.

Take Venera Ibragimov, a mother of three who speaks Turkish and Russian at home. Ibragimov studied English at the City of Richmond's Adult Career Development Center for two years and completed one semester at J. Sargeant Community College. She emigrated from Russia with her husband and mother-in-law, all of whom are of Turkish heritage.

While Ibragimov studied English, she raised her children and worked outside the home. Her husband, meanwhile, worked two jobs, leaving him no time to formally study English. This makes Ibragimov the family's head English speaker. Once it became financially possible, the family bought a house in Henrico—"for the better schools," Ibragimov said.

"My children are very happy at Pinchbeck," she added. "The teachers take their time. My daughter, Arzu, is very shy, and they bring her out."

Arzu, eleven, agrees: "When I first came to the school, I felt like the other kids were staring at me."

Such shyness is common to ESL children as they adjust to a new place, culture and language, regardless of the strength of a school's ESL program, Donovan said.

Pinchbeck held its first International Festival in 2013 as a way to celebrate the school's increasing diversity and encourage international students' pride in their home culture.

"At the festival, I was very proud of where I'm from," says Ignacio "Nacho" de la Sancha, ten. He dressed as a Mexican vaquero, or cowboy, and brought traditional tamales to the event.

Despite the fun days, the educational schedule can be unrelenting.

"I have a child who's been in this country two weeks and already has to take the math [Standards of Learning exam]," Donovan said. "Teachers need to be passionate about making sure all children receive an education. Luckily our principal [Kirk Eggleston] is very supportive of ESL students' needs."

Not just students—parents, too. Since 2006, Henrico County Public Schools has operated a Welcome Center to assist ESL parents with the process of school registration and orientation.

"The Welcome Center provides additional resources to families for enrollment, in case they do not understand the American school system or there's a language barrier," said Valerie Gooss, head of the HCPS Welcome Center.

Gooss said ESL parents typically go to the child's home school to register their children and are then referred to the Welcome Center. Should they need an interpreter, the center has two full-time Spanish interpreters and one French interpreter. Interpreters of other languages can be requested with two-week lead time.

While the parents register their children for school, each child takes an English-proficiency test. The center helps eligible parents apply for free and reduced-price lunches and finds affordable health services for immunizations.

"I think the Welcome Center does exactly that: it welcomes families to the school system," Gooss said. "It gives them the confidence to approach the school. Once they meet the staff there, we're an ongoing resource. ...We're just another layer of support."

Common ESL pedagogy claims that it takes six to ten years for a child to reach the language proficiency of a native English speaker. But that range can be deceiving, Donovan said. "A lot of it [a child's English acquisition] depends on the parents' socioeconomic status in their home country, which influences how parents relate to us as educators. There are a lot of cultural differences in how education's administered in other countries."

For example, she explained, the idea of using math to understand US money can be particularly difficult for ESL children. "An activity like 'Show me how to make change' usually takes them a while."

Donovan would like more funding for ESL classes, but she said the most important factor for improved results in Henrico costs nothing: more outreach and kindness from American-born, English-speaking parents toward immigrant ESL parents.

Entering US society can be difficult, particularly for children. When Brian Vigil Cruz, twelve, moved to Henrico from Honduras, some of his classmates bullied him, he said, by "calling me 'Mexican' in a mean way."

The boy's eyes filled with tears as he described his hurt that his classmates did not understand, or seem to care about, the differences between Honduran and Mexican cultures. "But that doesn't really happen anymore," he said as a smile returned to his face.

Aaron Sreng, eleven, whose family is from Cambodia, said he was initially "really nervous" around his classmates. But as he participated in ESL courses, his nerves faded. He is particularly proud of his advances in English: "They told me I was doing a good job."

## PAROCHIAL SCHOOLS

"Like a mosaic made of tiles in beautiful colors…" is the Spanish-language pamphlet tagline that introduces readers to ¡Venga!, the Arlington Catholic Diocese's initiative started in 2015 to increase Hispanic student enrollment in diocesan schools from McLean to Winchester.

Of the 17,234 students enrolled in diocesan schools during the 2014–15 academic year, about 10 percent self-identified as Hispanic. Yet that

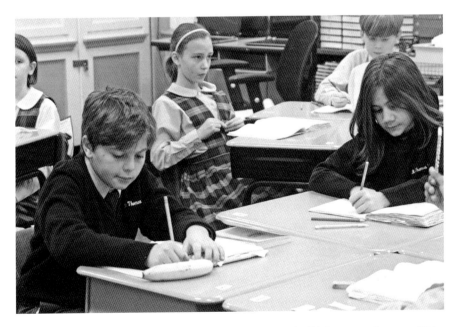

Spanish is the most widely spoken language among Virginia's English Language Learners. This photo depicts children in English class at Arlington's St. Thomas More School. *Christine Stoddard.*

percentage does not match the trending growth in Northern Virginia's Hispanic communities or Catholic parishes.

From 2000 to 2010, Fairfax County's Hispanic population increased from 106,958 to 168,482. During the same period, the city of Fredericksburg's Hispanic population grew from 945 to 2,607.

According to CARA, a Catholic research center at Georgetown University in Washington, 34 percent of US adult Catholics are Hispanic, compared to 58 percent non-Hispanic whites, making the Hispanic population the second-biggest Catholic demographic in the country.

One of the difficulties in recruiting Hispanic students for the Arlington Diocese's parochial schools is the lack of a diocesan-wide English Language Learning program or regular translation and interpretation services for newly immigrated parents.

According to the Virginia Department of Education, per the No Child Left Behind Act, under Title I of the Elementary and Secondary Education Act, "local educational agencies (LEAs) are required to provide services for eligible private school students as well as eligible public school students." While Catholic school students are included in this measure, the lack of such language services in diocesan schools makes them dependent on the public schools for relevant resources, including teachers certified in teaching English as a Second or Other Language.

In March 2015, the US Department of Education's Office of Non-Public Education co-presented with the Diocese of Arlington at the National Catholic Educational Association's annual conference in Orlando. The session sought to to open a dialogue about how public and Catholic schools can share resources, including but not limited to language resources. "Let's Collaborate" presenters included Pamela Allen of the US Department of Education and Diane Elliott, special services coordinator in the Arlington Diocese's Office of Schools.

"We shared how the Virginia Department of Education works with private schools for programs under the Elementary and Secondary Education Act," said Elliot. "Services for students whose first language is not English is one of those programs."

Another barrier to increasing Hispanic enrollment in Catholic schools is culture, said Renée Quiros-White, diocesan director of enrollment management, who explained that translating promotional materials and enrollment paperwork is not sufficient for generating Hispanic interest in Catholic schools.

While the Office of Catholic Schools has sought translation support from the diocesan Spanish Apostolate, Quiros-White hopes to adopt some of the cultural measures taken by the Diocese of Richmond.

One of the challenges faced by Virginia's Catholic parochial schools is lack of funding for a dedicated English Language Learning specialist. *Christine Stoddard.*

Annette Parsons, Richmond's chief educational administrator, who started the Hispanic enrollment initiative Segura in 2009, said that a talk at the University of Notre Dame in Indiana helped her realize that creating Spanish flyers and documents was not enough.

After consulting Richmond bishop Francis X. DiLorenzo, Parsons established a madrina, or godmother, system in which schools could hire a bilingual Hispanic mother to assist other Hispanic parents five to ten hours a week. Familiar with the language and the commonalities among Latin American cultures, the madrina helps organize lunches and performances that allow Hispanic families to share their food, songs and dances with the greater school community.

When Segura started, Richmond had two Hispanic students in its diocesan schools. Today, that number has grown to three hundred.

"Food and music are great equalizers," said Quiros-White, who added that while Arlington is not collaborating with Richmond on its Hispanic enrollment initiative, "we are inspired by the success of Segura."

Financial limitations also may prevent more Hispanic parents from enrolling their children in Catholic schools.

As of the spring of 2015, $2.8 million worth of need-based assistance is made available through the Diocesan Tuition Assistance Program, and

$91,220 is made available through the Diocesan Scholarship Foundation. Also, $11,824 in special tuition assistance is made available for single parents with multiple children in Catholic schools. With ¡Venga!, more funds may be made available for Hispanic families who complete the necessary paperwork.

¡Venga! is part of the office's five-year strategic plan, which aims for, among other things, outreach and diversity. In the plan's summary brochure, Arlington bishop Paul S. Loverde states, "We have received the gift of baptism and share in the responsibility to fulfill Christ's final command to 'go out and teach' (cf Mt. 28:19). Our schools are a vital part of this evangelization among educators, students, parents and our wider communities."

In an official statement, Sister Bernadette McManigal, superintendent for diocesan schools, wrote:

> *Opening our school doors to more Hispanic students is an opportunity for evangelization. It is also an opportunity to show our appreciation of the many cultures that comprise our world and to learn from these cultures. Welcoming students reminds us of the expansiveness and welcoming attitude of our God. I look forward to this new initiative on the part of our Catholic schools, new in the sense of a more deliberative outreach to these neighbors.*

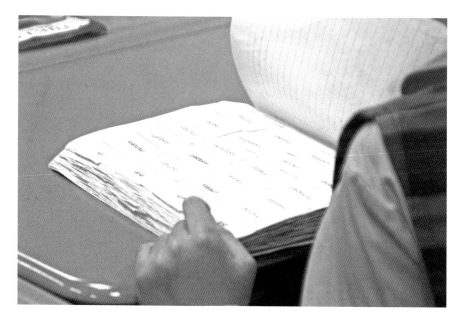

According to a 2014 state profile put together by the Education Commission of the States, more than ninety thousand Virginia students require English Language Learning instruction. *Christine Stoddard.*

## NON-SPANISH-SPEAKING LATINOS

One newspaper article I will never forget is Melissa Scott Sinclair's "The Rain People." It ran in *Style Weekly*, Richmond's alternative weekly newspaper, in August 2011 and introduced the particular plight of Richmond's Mixtec community. I had never heard of Richmond having any significant American Indian population, let alone one from Mexico. Many European Americans and African Americans might see Mixtecs out in public and assume they are Hispanic, but they completely lack Spanish heritage. Because of Latin America's own social hierarchy, Richmond's Hispanic community has ostracized the Mixtecs. They were—and remain—othered by the other.

In public education, the philosophy of doing the greatest good for the greatest number reigns supreme. The Richmond public school system illustrates this point in its English as a Second Language program. In a school system where nearly 90 percent of students are African American and native to Richmond, serving immigrant communities—especially obscure ones— can be a secondary priority.

ESL resources are clearly targeted toward the Spanish-speaking members of the city's thirteen thousand Latinos. Latino Indians, like the Mixtecs of Mexico, cannot reap the full benefits these programs offer because Spanish is not their native language.

In terms of language and culture, the casual observer might not notice much difference between Richmond's Mixtec community and any other Latino immigrant group in the city. Neither would the average non-Spanish-speaking teacher, school counselor or education specialist. For both the Mixtecs and their allies, however, the distinction is all too evident.

Richmond's Mixtecs hail from the small, isolated village of Metlatónoc, in Mexico's southwestern state of Guerrero. They are pure Amerindian, not of Spanish descent and speak their own Mixtec language, which belongs to Mexico's Otomanguean linguistic family. This linguistic family represents a cluster of languages spoken by more than 500,000 Mexican Amerindians, though the number of people who speak the same dialect as Richmond's Mixtecs is much smaller.

"Their Spanish is not very good," said Father Shay Auerbach in a 2012 interview. At the time, he was the pastor of Sacred Heart Church, where most members of the Mixtec community attend Mass in the city's Manchester district. "And some of them don't read and write, period—whether that's Spanish or anything."

The Mixtec Women's Co-Op is a Mixtec handicraft group managed by Sacred Heart Center. *Christine Stoddard.*

Like many school systems in Virginia, the Richmond school district has designed its ESL program with Spanish speakers in mind. The district's Office of the Bilingual/ESL Parent Liaison, for instance, ensures that school documents and announcements are translated into Spanish for parents, but not necessarily into other languages.

The problem extends to the suburbs as well. Henrico County Public Schools, for instance, employ a Latino liaison, but that person is trained to assist Spanish-speaking Latinos only.

Auerbach said illiteracy exacerbates the Mixtecs' language gap.

"Mixteco is a written language, but many of them may not know it," he said. Only some schools in Mexico teach indigenous languages, Auerbach noted.

Mary Wickham, director of the church-affiliated Sacred Heart Center, said the language barrier varies throughout the Mixtec community.

"The children speak beautiful English," Wickham said. "I don't know how their Spanish is, but they probably speak better Mixtec English than Spanish."

Paradoxically, learning English at school could be both helpful for the Mixtec children and detrimental to the communication gap between their parents and the schools, Wickham said.

This photo shows the details of an embroidered kerchief made by a member of the Mixtec Women's Co-Op. *Christine Stoddard.*

"Kind of the pattern is, whether it's Spanish-speaking people or Mixtec-speaking people, that the children are learning English faster than the parents because they're in school," she said. "And so they become the translators, which can be good but also can have a downside because it puts a lot of responsibility on children and can put them in situations that they shouldn't really be involved in."

Such responsibility may also weigh down on children whose parents speak other foreign languages.

As of 2012, the Richmond Public Schools had 21 ESL teachers. That year, the district reported serving about 1,000 students with limited English proficiency. Those students speak about thirty different languages, from Afrikaans and Arabic to Vietnamese and Yoruba. The vast majority—more than 770 of the students—speak Spanish.

The number of limited-English-proficient students has grown dramatically in Richmond and across Virginia in recent years. Eight years ago, for example, Richmond had fewer than four hundred students needing ESL services.

## Achievement Gaps

When I enter Ana Bonilla-Galdamez's office for our scheduled interview in April 2015, she is on the phone discussing the deportation hearing for one of her students at Charles Barrett Elementary School in Alexandria.

As she continues her conversation, I scan the toys, books and student drawings that line the shelves and walls. One sign reads, "Parents make the difference" in Spanish; another outlines rules, from sharing to listening. Extra food, shoes and educational pamphlets fill cabinets and cubbies. This is not just an administrative space but a refuge.

"Sorry," Bonilla-Galdamez said sheepishly. "I had to take that."

And I have her full attention until dismissal time, when parents and students line up at her door. She listens to their concerns one by one, asking questions rather than issuing instructions.

This is why the National Association of Social Workers, the largest professional membership group in the field, named Bonilla-Galdamez Social Worker of the Year in 2015. It is one of the four awards the association gives out each year to those seelected from its 150,000 members; the other three are the Lifetime Achievement Award, the Public Elected Official of the Year Award and the Public Citizen of the Year Award.

"Ana strikes a balance between [enforcing policy] and taking a parental approach," said Seth Kennard, principal at Charles Barrett. "That's what makes her approach a holistic one."

Kennard explained that more than one-third of Charles Barrett's student population qualifies for free or reduced lunch, which is not high enough for the school to be classified as Title I, or high poverty. Because of this, Charles Barrett does not receive federally mandated resources allotted to Title I schools, despite a relatively high level of need.

"So we make do with less," said Kennard, but "Ana is good at getting outside entities to help the students."

Bonilla-Galdamez attributes her success to a work ethic deeply rooted in faith.

"I need to fill my spirituality cup because spirituality is part of being balanced," she said, explaining that balance, not perfection, is what allows her to assist students and families.

Bonilla-Galdamez, who now lives in Lorton, came to Hyattsville, Maryland, with her family at age twelve to escape the civil war in El Salvador.

"We left everything," she said. "What we had were things people gave to us."

When they first arrived, Bonilla-Galdamez and her family relied heavily on the generosity of a nun at el Centro Católico, the Spanish-language Catholic Center run by Catholic Charities of the Archdiocese of Washington, for basic necessities.

"When we ate, we ate what Hermana Maya gave us," she said. "I also faced the harsh reality of my parents working day and night, and in a sense, I became my little sister's mother."

Unable to speak English, Bonilla-Galdamez found a community at St. Camillus Church, a Franciscan-run multicultural parish in Silver Spring, where she started attending Spanish-language youth group with her older brother.

"In San Salvador, I grew up a traditional Catholic, going to daily Mass and weekly confession," she said. "But you didn't live your faith."

That soon changed because of youth group, which she said distracted her from the bullying she endured at school because of her accent and above-average height.

"I would go to bed crying and praying, asking why," she said. "But I knew that on Sundays, I was going to be happy, accepted. The church was my lifeline."

She assisted with Youth Mass, organized fundraisers and performed community service. When the church's confirmation teacher "dropped off," Bonilla-Galdamez, then fourteen, said she taught the rest of the class.

Bonilla-Galdamez began spending so much time at the church and with her youth group that her mother started to complain about her not spending enough time at home.

"Youth group gave me the socialization that teens crave," she said. "It gave me a sense of identity."

Outside of youth group, Bonilla-Galdamez contended with more than just cultural barriers and her classmates' torment. At fourteen, she started her first job cleaning toilets. Before graduating from high school, she also worked as a cashier at a fast-food restaurant and as a clerk at a money-order office.

She said that other youth group members had it hard, too. Some of them had immigrated to the United States by themselves. Every year, the youth group put on a big Christmas party, in part to stifle homesickness.

Still, Bonilla-Galdamez admits that, even with the support of youth group, it was hard to be in a new place. During her first year of high school, she began to act out—"nothing major, no spiraling down"—and got in trouble with a few fights at school. She said that today when students fight, she sees herself in them, trying to fit in or to vent their frustrations over problems at

home. When she experienced her own bout of rebellion, it was her youth group pastor who got her back on track. He started asking her to come up with topics for retreats and skits.

"Sometimes [young Catholics] spit out the words and don't think about what [they're saying]," Bonilla-Galdamez said. "But ever since that youth group *Padre Nuestro* (Our Father) skit, I know exactly what I'm saying."

At her pastor's prompting, she went on to study at St. Bonaventure University in New York, the first Franciscan university established in the United States, after completing a year of community college.

"With faith, you learn to give, have hope, believe and always pray," she said. "St. Bonaventure was not very diverse [back then]. I would go to the chapel by myself, pray in Spanish and cry."

The campus did not offer Spanish Mass, and because Bonilla-Galdamez never learned how to pray in English, she felt uncomfortable in English Mass. She wanted desperately to worship in her native language.

"Sometimes ideas pop into my head, and I just go with them," she said. "I was working in the university Language Department at the time, so I asked the Spanish teacher if she would offer extra credit to her students if they went to Spanish Mass. She said yes. So I went to the friary, and they let me celebrate the first campus Mass in Spanish. I read and sang in Spanish, and Spanish-speaking kids and Spanish students actually came."

Because of her, Spanish Mass became an annual tradition.

After graduating in 1993, Bonilla-Galdamez went on to earn her master's degree in social work from Catholic University in Washington. Since then, she has spent nearly twenty years in Alexandria public schools.

She started her career at T.C. Williams High School's Minnie Howard campus, where she said teens would ask her questions about faith, one-on-one or in an after-school program she offered.

"Intellectually, we [school staff members] teach them to add and read," she said. "Physically, we offer PE and meals. Emotionally, we have counseling. But what do we offer them spiritually?"

Bonilla-Galdamez said that, in a public school like Charles Barrett, she cannot discuss faith matters unless students or parents initiate the conversation. When they do, it affects how she talks to them.

"When a child's parent dies and the child starts asking about heaven, then I will talk about heaven," she said. "Many parents will cry about their kids not making the right choices. If they talk about praying for them, then that opens the door."

But regardless of a student's faith background, Bonilla-Galdamez helps—"always to the maximum, with love, service and compassion, straight from the heart," said Molly Zametkin, Bonilla-Galdamez's mentee and a graduate social work student at Catholic University.

"She is the eternal flame of social work," said Zametkin. "She helps people with respect for their human dignity and autonomy. For her, it's not about doing things for someone; it's about being by their side and giving them the right resources."

Zametkin cited a few examples of Bonilla-Galdamez's efforts, such as a program for Latino parents, a community student mentoring program and a self-esteem focus group for fourth and fifth grade girls.

Bonilla-Galdamez, who splits her time between St. Camillus Church and Good Shepherd Church in Alexandria, where one of her sons recently started CCD, was honored on April 30, 2015, at the Omni Shoreham Hotel in Washington, DC.

"This is my ministry," she said. "I'm no different than any other immigrant. My mother cleaned houses. My father was a chauffeur. I was an at-risk kid. But God put me on this path."

# BUSINESS AND GOVERNMENT

*Since I came here in the 1960s, Roanoke has gone from being a sleepy, segregated town to being a city of extraordinary diversity. Today we proudly celebrate having more than 104 different nationalities.*
—*Roanoke mayor David Bowers,* Washington Post, *March 2, 2014*

**H**istorically, Hispanics and Latinos have been underrepresented in Virginia business and government. But as in other spheres of society and influence, that is changing.

In 2003, Republican politician Jeffrey M. Frederick, who was born to a Colombian mother and an American father, became the first recorded Hispanic to ever get elected to a Virginia state government position. He served three terms as a member of the Virginia House of Delegates and as a member of the Republic National Committee. Ten years later, Governor Terry McAuliffe nominated Nancy Rodrigues to the cabinet role of secretary of administration.

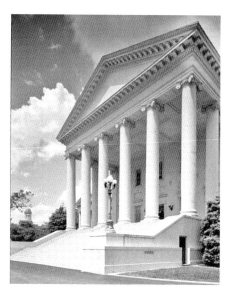

Hispanics and Latinos continue to seek increased representation in the Virginia State Capitol. *Library of Congress.*

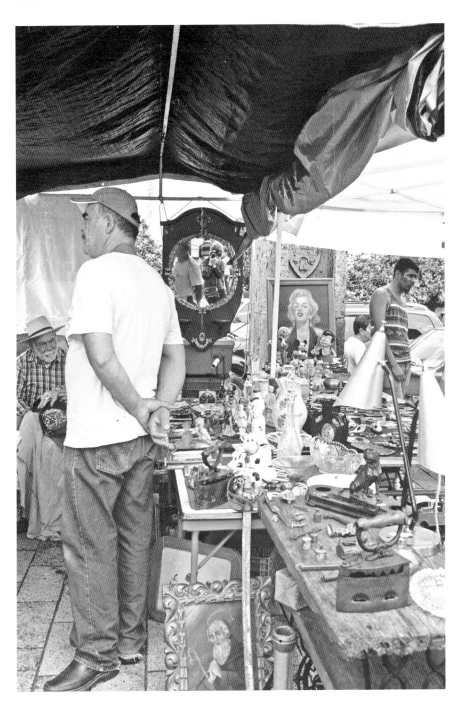

A man stands in a *tiangui*, or flea market, in Guadalajara, Mexico. *Helen Stoddard*.

Latinidad is forging its way into the state's business world, as well. According to a 2015 report issued by Fairfax County, 11 percent of the county's businesses are owned by Hispanics and Latinos. The percentage accounts for 9,600 businesses. They range from Alltech International, an IT services provider, to Centech, a federal government software contractor, but the most common sectors of Hispanic and Latino businesses are construction, administration and support. "Other," which accounts for 10 percent of Hispanic and Latino businesses, includes agriculture, utilities, arts, entertainment, recreation, accommodation and food services, educational services, finance, insurance and information. According to this same report, Hispanics and Latinos are most likely to be employed in the administrative and support professions, scientific and technical, construction and "other" sectors ("other" being the aforementioned fields).

Restaurants may not make up the biggest sector of Virginia's Hispanic and Latino businesses, but they are some of the most visible and most beloved. People form an allegiance to food. They grow attached to a place and may even have a favorite table. They become close to their favorite server, especially if that person memorizes their favorite order. People remember food and restaurants and tables and servers years after a place goes out of business. Restaurants are an essential part of any town's cultural landscape.

Arlington and Alexandria boast a wealth of Latino culinary options. Mexican and Salvadoran restaurants are especially popular, but Bolivian and Peruvian restaurants are easy finds, too. These range from Los Tíos in Alexandria's Del Ray neighborhood (which serves fine Tex-Mex and Salvadoran food) to Arlington's Pan American Bakery on Columbia Pike (which specializes in salteñas, or Bolivian-style empanadas). Other examples of Arlington and Alexandria Latino restaurants or restaurants with a strong Latino influence include Casa Felipe, Los Cuates, El Paraiso I & II, Pilar's Restaurant, Uncle Julio's, El Paso, Guapo's, Taqueria el Poblano, La Union, El Ranchero Bar & Grill and Mexicali Blues.

La Tasca is a Spanish restaurant with locations in Old Town Alexandria and Arlington's Clarendon neighborhood, as well as DC and Maryland. It serves typical Spanish dishes, including tapas and paella, in addition to sangria and Spanish wines. The Alexandria location is popular for its flamenco shows and Rumba nights. Héctor Márquez (singer), Edwin Aparicio (dancer), Sara Jerez (dancer) and Ricardo Marlow (guitar) perform two flamenco shows every Wednesday and Thursday. Richard Marlow, Jose Oretea and Héctor Márquez play three hours of Rumba every Friday.

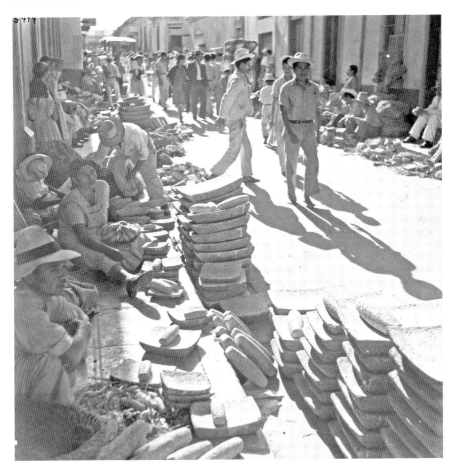

Marketplaces have long been the site for buying, selling and trading goods in Latin America. This archival photo shows a traditional market in San Salvador. *Library of Congress.*

Another notable Northern Virginia restaurant is Anita's, which serves New Mexico–style Mexican food. The Tellez family founded the first Anita's location in Vienna in 1974 after moving from Albuquerque to the Washington, DC area. Anita, Phil and their son, Tom, pride themselves on their New Mexican–style green and red chile sauces: "From day one, Anita has always insisted that the chiles used in her recipes come exclusively from the motherland, and those of you who have enjoyed them before certainly know why." Anita's now has eight locations in Loudoun and Fairfax Counties: Ashburn, Burke, Chantilly, Fairfax, Herndon, Leesburg and the original Vienna.

As Fairfax's Latino population continues to grow, its options for Latin American fare grow, too. Other Latino restaurants in Loudoun and Fairfax

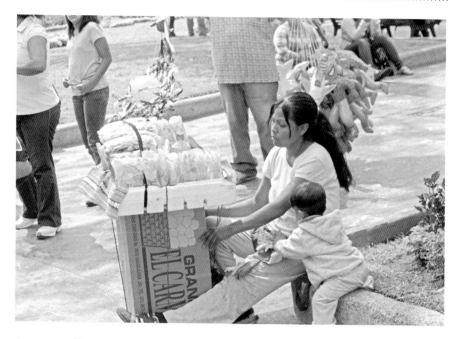

A woman sells snacks at a plaza in Guadalajara, Mexico, on a summer day in 2012. *Christine Stoddard.*

Counties include El Carbonero, El Puente de Oro, Pupuseria El Buen Gusto and Two Amigos Mexican Restaurant.

Guatemalan businessman Dionisio Gutiérrez Gutiérrez founded the Pollo Campero franchise in 1971. Since then, the chain has grown to more than 350 locations, with 50 in the United States. Though the first US location opened in Los Angeles in 2002, the business's US headquarters is in Dallas, Texas. Its sixth and newest Virginia restaurant opened at 7705 Richmond Highway in Alexandria in September 2014. In February of that year, Pollo Campero opened its first Richmond location at 7800 Midlothian Turnpike.

La Milpa is a traditional Mexican and Salvadoran restaurant, social hotspot and market in Southside Richmond. Since opening around 2000, the establishment has maintained a twenty-four-hour, 7-day-a-week, 365-day-a-year schedule. Popotillo, or Mexican straw art, adorns the walls. On occasion, La Milpa hosts outdoor theater featuring Juan Salinas. The business also caters and runs a lunch van.

Kuba Kuba was founded in 1998 by Cuban American chef Manny Mendez. *Style Weekly* describes Richmond's other Cuban restaurant, Havana 59, as "like Cuba in the 1950s." Havana 59 is across from the Seventeenth Street Farmer's Market, which is poignant because the market was once a

Vendors sell a range of handicrafts in a small town in Jalisco, Mexico, on a summer day in 2012. *Christine Stoddard.*

place where African slaves were bought and sold and Cuban food shows a strong African influence.

At present, Charlottesville has several Hispanic and Latino restaurants: Aqui es Mexico, El Puerto Mexican Restaurant, El Tepeyac, La Taza Coffee House, Al Carbon Chicken and Más.

In Virginia Beach, the popular Tres Amigos Mexican Restaurant opened in 1999. Other local Latino restaurants include Cancun Fiesta, Side Street Cantina, Gringo's Taqueria, Pelon's Baja Grill, Cactus Jack's Southwest Grill, La Michocana, Las Palmas and Guadalajara Mexican.

In the Roanoke area, the best-known Latino eating establishments are two family-owned restaurants with six locations: El Rodeo and Toreo. On Yelp.com, Liam C. wrote the following on April 3, 2015:

> *On a long road trip we stopped for the night at the Hampton Inn and they suggested this restaurant. I am glad they did. The portion size was large and very reasonably priced. I had the steak fajitas and it was very delicious. I would suggest this restaurant to anyone and if I ever find myself going [through] Roanoke again, I would [without a] doubt go here again.*

In Latin America, many people make a living by running their own food carts. *Christine Stoddard.*

Figurines depicting animals and religious characters abound at Latino markets throughout North and South America. *Christine Stoddard.*

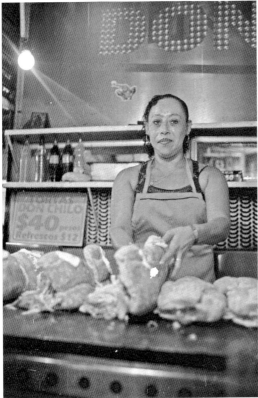

*Above*: Beads and jewelry are common finds at many Latino markets in Central and South America, as well as in the United States. *Christine Stoddard*.

*Left*: A woman sells *tortas ahogadas* at San Juan de Dios, a massive marketplace in Guadalajara, Mexico. *Helen Stoddard*.

Latino food trucks and food stands also have picked up in Virginia, particularly in urban areas. Most carry Salvadoran and Mexican food. The Arlington/Alexandria/Falls Church area alone boasts Torta Y Tacos La Chiquita, La Tingeria, El Chilango, Pa' Tacos El Papi, Pedro & Vinny's, El Charrito Caminante, District Taco Cart, Pupusería Diana, Latin & American Flavors, Guajillo, Jarochita #2, Fuego Cocina y Tequileria, A' Lo Cubano, Comida Latina Express, Living La Chiva Loca, Blancas Sabor Latino, Project Milanesa, Honduran Food Truck, Tortuga Truck and Tacos El Torito, and this is just the start of the list.

Of course, not all Virginia Hispanics and Latino businesspeople open restaurants specializing in their home country's cuisine. Take Nora Partlow, who founded St. Elmo's Coffee Pub in Alexandria's Del Ray neighborhood, which she sold toward the end of 2015.

Partlow was born in 1949 in Cuba and has lived in Alexandria since 1985. During a 2014 interview, she recalled growing up on her grandfather's farm outside of Holguín, Cuba, before moving to New Jersey, attending school in the United States, getting married and coming to Virginia to live her dream: running St. Elmo's.

What follows is the transcription of the aforementioned interview, which an uncredited volunteer conducted in 2014 for the Alexandria Archaeology Museum's oral history collection and the new project "Immigrant Alexandria: Past, Present, and Future." In March 2015, I transcribed the interview for those unable to visit the museum.

### INTRODUCTION AND CHILDHOOD IN CUBA (00:00:02)

| | |
|---|---|
| Interviewer: | Good morning. Today is March 25, 2015. I'm interviewing Nora Paltrow— |
| Nora: | Partlow. |
| Interviewer: | Partlow—pardon me—who owns St. Elmo's Coffee Pub in Del Ray, Alexandria. I might add, a very popular and lovely place. |
| Nora (overlapping): | Thank you. |
| Interviewer: | That I have been to many times. And we are going to talk to Nora about her life and especially about her immigration to this country and to Alexandria in particular. So Nora, why don't you start? I have your birthday down here as May 1949, and tell us where in Cuba you were born. |

Nora:

OK, I was born in a smaller area called Holguín, which actually is not a small area. It's, I believe, it's the second-largest city in Cuba, and it's on the western part of the island. And, um... (long pause)

Interviewer:

This is before the revolution now.

Nora:

Oh, definitely! Yeah, 1949, definitely before the revolution.

Interviewer (overlapping):

OK.

Nora:

It was, um, I guess after the war. You know, World War II.

Interviewer (overlapping):

OK...OK.

Interviewer:

And tell us a little bit about your childhood.

Nora:

My childhood was really, really wonderful because, actually, I was raised, after I was born, um, my, uh, grandfather on my father's side owned a dairy farm. But in Cuba, a dairy farm is not just a dairy farm. There [were] also orchards, there was [a] plantation of, um, bananas, which we call plantains here, you know, and, uh, let's see...what other crops did he do? Besides the orchard, the orchard had, um, oranges, lemons, limes, um, what other fruit? Papayas.

Interviewer:

Wow, did you help him farm?

Nora:

No, but I observed because I was very young, and I think the fun part for me was that I was very free. I mean, since the time that I was able to walk, I was able to roam, and I think that is the most wonderful thing for a child to have is that availability of not being afraid of anything.

Interviewer:

So you lived on a farm?

Nora:

Yes.

Interviewer:

And your parents?

Nora:

Yes.

Interviewer:

And did you have siblings, as well?

Nora:

At that time, no. I'm the eldest.

Interviewer:

You're the eldest?

Nora:

The eldest of three.

Interviewer:

OK.

Nora:

And my brother came about four years later, so we're four years apart. And then my sister was born here in the United States.

Interviewer:        OK.

Nora:               But anyway, it was a wonderful place to grow up, um, especially that, from birth to age seven. Uh, we lived in Havana, um, probably a couple of years before we migrated to the United States. Um, my father was, um, one of five in his family, so, you know, as rural people, you helped y-your father, and so he helped at the farm. But at a very young age, he always had other ambitions. And he always wanted to study more and, um, he felt that the United States would give him that opportunity because at that time, that time of the '40s really in Cuba, there was only two societies: the very rich and the p—there was really no middle class.

Interviewer         No middle class.
(overlapping):

Nora:               Even though in, if we look back, we could consider my family, both on my mother's side and my father's side, so, middle class because they had those types of occupations, not just farming, but, um, shop owners, accountant, uh, teachers. You know, so, I'd consider that middle class.

## LIFE IN THE UNITED STATES:
## AGE SEVEN THROUGH HIGH SCHOOL (00:03:57)

Interviewer:        And so, when did your father decide that you should come to the United States?

Nora:               In the middle '50s. And, um, it was his—

Interviewer:        And you were how old?

Nora:               I was seven. I was seven. And we came through New York City, so Kennedy Airport, uh, that was our—we didn't come through, most people think Cubans come through Miami, but at that time really, Miami wasn't really the big thing. It wasn't after the revolution that then migration—

Interviewer         And I always think that people come by boat from
(interrupts):       Cuba. (laughs)

Nora:               Yeah, no.

Interviewer:        But, yeah, no, you came by air.

Nora:               QWA.

Interviewer:        Yup.

Nora:               Yup, the big airplane at the time.

Interviewer:        So where did you live first?

| | |
|---|---|
| Nora: | We, um, migrated to, uh, a little town called Perth Amboy in, uh, New Jersey. And I believe we went there because that's where was a small enc—what's the word? |
| Interviewer: | Enclave. |
| Nora: | Enclave, yeah, um, of Cubans, which would include my uncle and some of, people that he knew from Cuba. Just like any immigrant, you know, group, they like to stick together. |
| Interviewer: | Right. |
| Nora: | To support each other. And to help each other find jobs. And since it was a time, even though my father tried to learn English through the old system of mail order (laughs), you know, school. Remember? |
| Interviewer: | Right. |
| Nora: | Learning that way. He tried to do that prior to coming here, but of course, learning that and the actuality was totally different, so it took him a while, you know, to learn to converse in English. |
| Interviewer (overlapping): | Did you know any English? |
| Nora: | None. Both my mom and my brother and I had no English whatsoever. So I was plopped in a school where I was the only Hispanic girl. Everybody spoke English, no other language. |
| Interviewer: | How did you survive? How did you— |
| Nora: | Well, like everybody survives, you know. Uh, within, I came, let's see, at the end of the school year, which I think it was April. And, uh, by September, they kept, because it was the end, I had already finished third grade in Cuba, but I was, had to repeat it again because I didn't know the language. They didn't have any kind of transcripts or stuff like that, just started from scratch, just like that. So, by September, I was good to go and from then on— |
| Interviewer: | From June to September? You learned— |
| Nora: | Yup. |
| Interviewer: | Through television or...? |
| Nora: | Um, just being immersed because that's all you heard was English. There was nobody else. |
| Interviewer (overlapping): | Did your parents— |
| Nora: | I only spoke Spanish at home. |

| | |
|---|---|
| Interviewer: | I was just going to ask that. |
| Nora: | Oh, yeah. Spanish at home. So I'm bilingual. Totally bilingual. |
| Interviewer: | Totally bilingual. |
| Nora: | I write it, read it because, then when I went to school, um, especially high school, I took Spanish all four years, which a lot of people say, "Why would you do that if you were already know how to speak it?" Well, just like you take English |
| Interviewer (overlapping): | (laughs) Yeah. |
| Nora: | You have to learn how to write it (laughs), properly write it and read it and learn literature and all that kind of stuff, so that's why— |
| Interviewer: | And you might be the smartest person in the class, right? (laughs) |
| Nora: | Well, you know, I was in a way because my English, I mean my Spanish, teacher was really wonderful and she felt that I would make a wonderful Spanish teacher, so she sort of, you know, was keeping me and we had, um, I think once a year, we would have where the students became the teacher. So I had that. I did that. That was kind of cool, you know, for me, um, being able to do that. And she said, "Oh, Nora, you would make a wonderful teacher and you should follow that." But of course I had other plans, and I wanted to be a businesswoman. |
| Interviewer: | But I heard— |
| Nora: | What? |
| Interviewer: | I heard that you started taking leadership pretty early. |
| Nora: | Yes. |
| Interviewer: | Did I see something about you taking class treasurer or something? |
| Nora: | Oh, yes. Oh, yeah. Definitely. I was always, um, I was always picked to be class president, things like that, but I didn't want to be president. I wanted to handle money. |
| Interviewer: | (laughs) |
| Nora: | It's funny, but it was (claps). I remember in eighth grade— |
| Interviewer: | You knew where the power was. |

| | |
|---|---|
| Nora: | I know where the power is. And in eighth grade, um, when they told me, you know, "You gotta run for president," and stuff like that, Joey Ruella, I talked him into—that was a fella that I was really close to in my eighth grade class—I said, "You be president. I'm going to be the treasurer." |
| Interviewer: | (laughs) |
| Nora: | So we just gave ourselves that title and, of course, everybody voted for us, and that's what we became. (laughs) |
| Interviewer: | (laughs) And you did the back room deal pretty early there? |
| Nora: | Yes. Yes, so, in every—once I went into high school, it was the same thing and the clubs, I would always volunteer to be the cashier in any kind of, you know, fundraiser or anything like that. I always handled monies. So... |

## The Cuban Revolution (00:08:26)

| | |
|---|---|
| Interviewer: | Now, during those high school years, were you sort of keeping touch with what was going on in Cuba? |
| Nora: | Oh, definitely. Yeah. |
| Interviewer: | How did you— |
| Nora: | My dad, my dad actually supported Castro because of the r—what was happening at that time when he left was that Bautista was in power and he really was for the rich. And, really, what we needed...It's really sort of what's happening here in the United States now. That the people with power are controlling everything. They're in control of everything. And at that time, there was two powers. There [were] the Americans that owned all the plantations, the coffee, the sugar, all those because they were in cahoots, just like the Mafia was in cahoots with Cuba. If you read any about Cuba's history, during that time, there was a lot of Mafia involved with the government and what they did. |
| Interviewer: | Mafia, as in Italy? |
| Nora: | No. United States. |
| Interviewer: | Oh. |
| Nora: | From the U.S. |
| Interviewer: | OK. |
| Nora: | You know, I can't think of some of those names right now, but they did all their business in Cuba. |
| Interviewer: | Because there was some economic advantage— |

| | |
|---|---|
| Nora: | Oh, yeah! All the—they did all the casinos, all the big clubs were all, like, pretty much owned by the Mafia. |
| Interviewer: | So when did your dad become disillusioned, or did he become disillusioned at some point? |
| Nora: | Well, that's one of the reasons why he came. Because I mean— |
| Interviewer (overlapping): | No, I mean after— |
| Nora: | He really couldn't have the opportunity, so he felt anybody else that was going to, you know, bring a difference, and he saw that in Castro, which a lot of the people did because, at the beginning, he was promoting—and Communism didn't blend in until after the fact, when the United States did not want to partner with Castro. So then who came to the rescue was the Communists. So then, that's when he partnered with them and so...they were going to help him. |
| Interviewer: | So did your dad and you all become disillusioned eventually with Castro? |
| Nora: | Yes. So even though my father supported him financially from here because there [were] many groups. One of them that I remember was called Alpha 66, which was some big organization here that fundraised for the revolution to support Castro. And, of course, everything turned around once they found out, really, you know, what was happening. And what was going to be, you know, with the dictatorship. |

## AFTER HIGH SCHOOL (00:10:51)

| | |
|---|---|
| Interviewer: | So let's pick up with your life. Uh, you graduated from high school. |
| Nora: | Yup. |
| Interviewer: | You indicated that you had an interest in business even then. |
| Nora: | Yes, yes. Actually, all my courses, at that time, I think the thing was, you either did business or you did college prep. Nobody, not even my, um, guidance counselor ever said, "Go to college and do business administration." Well, because then, women's choices...be a secretary, be a nurse. |
| Interviewer (overlapping): | Nurse. Teacher. |

| | |
|---|---|
| Nora: | Teacher. You know? That was the options. There wasn't any...there were none of the options that I wanted. Teacher might have been the only one, and it was only because of my Spanish teacher that had said that she felt, you know, I had those talents of being a teacher, which I think all my life I have taught, but in a different way. Because having [a] business, you have employees. When you're the boss, you have to teach. |
| Interviewer: | So what did you do right after high school? |
| Nora: | So, right after high school, I worked for a large corporation called Feder's, and they were manufacturers of air conditioning units, refrigeration. And I was a bilingual secretary for them right out of high school. |
| Interviewer: | And were you meeting men at this point? |
| Nora: | Oh, I think because of, you know, I don't see myself as attractive, but other—when you [have] long, black hair and straight, and being thin, and you know how we are when we're young, yes, I attracted—But, you know, I was never that kind of a girl. I was more interested in being myself. I never had any steady boyfriends during high school. I dated, but you know, had fun going to dances and all that kind of stuff. But I never—because I always felt that if you tied yourself down, if you committed to one person, you didn't have then a choice to experience everything else. |

## HER FIRST MARRIAGE (00:12:52)

| | |
|---|---|
| Interviewer: | But you did marry eventually. |
| Nora: | Yes. I did. |
| Interviewer: | And how old were you then? |
| Nora: | Actually, I didn't marry too young. I was twenty-one. And the reason—and it was a failed marriage. And it was because, my father, being the Hispanic, um, culture, he only, the only thing he told me, either you go to college, which, you know, we fought about because what he wanted me to go to college and what I wanted to do was totally different. I wanted to join the military, and that was during the Vietnam War. He said no. So, everything he'd seen that I wanted to do, he was contradicting me. So I said, "Well, what other choice do I have?" He says, "Well, the only way you leave my house is if you're married." So the first young man that said, "I love you," I said, "Well, this is my ticket." I'm out of here. So I agreed and I got married. He was a wonderful man, wonderful family. And what was really neat about it was— |

76

| | |
|---|---|
| Interviewer: | And you had children? |
| Nora: | Yes. And what was really neat about it was that my parents and my, um, first husband's family knew each other. Neighbors. So, of course, they, everybody approved of this wonderful marriage. And— |
| Interviewer: | Was he as young as you? |
| Nora: | Yeah, he was a little younger. One year younger. So everything worked out fine. I was actually married for about thirteen years, but even the day pri—or I should say weeks, prior to getting married, I was having these nightmares of like, "What are you doing? And w-how could—" But I said, "No, you know, everything's going to work out." So it was, you know, the demon inside saying, you know, telling me not to go ahead, but then (pauses) it was like a tug-of-war. And I said, "No, it will work out. You will be fine. You'll be able to—" |
| Interviewer: | It was expected in those days, right? |
| Nora: | Yes, yes. But remember the '60s was revolution for the women, so that was the big thing when we let go of pant— uh, the garter belts and we got pantyhose. And then, uh, women's lib— |
| Interviewer (overlapping): | Girdles. |
| Nora: | Right, with girdles. Uh, birth control pills. You know, all those things were introduced, which I was sort of part of. I embraced all that. You know, talk about, uh, what was her name? The one that has the— |
| Interviewer: | Gloria Steinem? |
| Nora: | Yes. I was such a fan. And actually, I got to see her live here finally about a year ago when her magazine celebrated fifty years or sixty years or something like that. It was pretty big. And a friend of mine, you know, invited me to go. She was at the, um, Press Club in D.C. And it was just, like, to me, that was like, MY GOD, because of all the changes that she had, you know, done for women. |
| Interviewer: | So during the thirteen years, though, you did have... |
| Nora: | Two children, a boy and a girl. |
| Interviewer (overlapping): | OK. |
| Nora: | Because I have four. |
| Interviewer: | Were you working during that marriage? |

Nora: No, but that was part of the...the...because I worked till the very, till I got married. And then once I got married, part of the rules were you became a housewife. And then of course, he had a good job so he could support me very well. But I struggled being an at-home mom. I wanted to be out there. I wanted to have the business. I wanted to, I wanted to do things. Being a mother was just not enough. So I struggled because I wanted to get out there, and he would always say to me, "No." I mean, I would try to do other businesses, you know, to start my own little businesses, and he would always say, "Remember, family comes first."

Interviewer: Were you still living in New Jersey then?

Nora: Yes.

Interviewer: OK.

Nora: Family comes first. And it wasn't till, hmmm, I mean, I— all those years, I struggled of, like, "What are you going to do? How are you going to get out of this? How are you going to move forward?" And because of that...was the main—I think if he would've agreed to that, I would've been happy living with him.

Interviewer: You mean if you had been able to work?

Nora: Exactly. Build a business, you know, get out there and be myself.

Interviewer (overlapping): If he made it a choice.

Nora: Yeah, and so, that was the breaking point, when I said, "I can't live." Because then I became depressed, very, very depressed.

Interviewer: How old were your children then?

Nora: Nine and eleven when I finally said, "Enough. I've had enough."

Interviewer: And they were in school all day?

Nora: And I said no. And we sat down. It was a very good kind of breakup because we—(laughs) I should've, I think that's where I would've made my money if I would've wrote everything down because we actually had, like, a powwow. We sat at the table, told the kids, and we told them the reasons why and we gave them a choice: "Where do you want to go, with Mom or with Dad?" And Mom was leaving. And that's when I came to Virginia.

### Coming to Virginia (00:17:35)

| | |
|---|---|
| Interviewer: | And was year was that? |
| Nora: | Eighty—'83 was when I made the decision. It took me two years to figure out exactly what I was going to do. |
| Interviewer: | Did you come straight to Alexandria? |
| Nora: | Yes. |
| Interviewer: | And your children did or did not come with you? |
| Nora: | No. We had shared custody, but because of the school and I didn't want to take them out of their home, um, it was like a visitation thing, back and forth. So I did that until they turned old enough they could go to college, and then they came with me. |
| Interviewer: | So what did you do when you first got to Virginia? |
| Nora: | I worked for a company. Prior to leaving New Jersey, I, um, became a rep for Party Light Gifts out of Massachusetts, and it's really being an independent, um, consultant pretty much and being your own business. And I had built a team of, like, thirteen, um, women working for me. So I had reached a top with them, and, um, which was really good. And I spoke to them about what I was doing with my personal life. They said, "Well, there's no reps in that area, so we're going to put you on a—" I've always worked also on, um, commission only. And you know, it's like a car salesman or like real estate. You really have to be very, very organized, very focused to make a living, to support yourself on commission only. And so I think I had that structure for myself. |
| Interviewer: | So you liked doing that? |
| Nora: | Oh, loved it. |
| Interviewer: | That was your mot—some people hate that, but— |
| Nora: | No. |
| Interviewer: | That was your motivation. |
| Nora: | That was my motivation. Because I know the sky's the limit. When that's available to you, the sky's the limit. And you really have to work, work, work, work everyday. You can't slack off knowing that you're going to get a paycheck on Friday, see? And, so, to me, that's why I've never really worked—a very short time in my working life have I worked for somebody else. I've always worked for myself. |
| Interviewer: | Wow. |

| Nora: | And, um, here, the only time I worked for somebody else was to find out how to, uh, work restaurants. |
|---|---|
| Interviewer: | So let me backtrack a little bit. You had this business with the seven people working for you. And you said you reached the top? |
| Nora: | Yup. I had reached the top. By that I mean, was that I was in management with them. And, um, then when I spoke to the president and I told him what I was doing, he said, "OK, go to Virginia. We'll put you on salary just so you can get your feet on the ground. And then work it." So I worked at that for a little while. |
| Interviewer: | And where were you living in Virginia then? |
| Nora: | I was living on, uuum, Braddock Road in an apartment. |
| Interviewer: | Pretty close to here. |
| Nora: | Yup, yeah, pretty close to here. So I've always been in this area, in the Del Ray area, Alexandria area. It wasn't until after I got married that we bought a house, and it literally is on the border. |
| Interviewer: | Now, wait a second. Married again? OK. |

## Second Marriage and Alexandria Entrepreneurship (00:20:34)

| Nora: | Yes, I got married in '85. |
|---|---|
| Interviewer: | OK, and I think I read that you— |
| Nora: | No, was it '85? Ei—I'm trying to think. We've been married (mumbles). You forget these dates. Uh, '83. Eighty-five was when I came. No, I didn't get married until '86. |
| Interviewer: | And you met, if I recall reading something, on a dance floor in Crystal City. |
| Nora: | Correct, correct. (Pauses) And it was a wonderful, um, thing because, at that time, the last thing I wanted to do, because I finally found my freedom to do whatever I wanted, was to get m—connected with, with a male. |
| Interviewer: | (laughs) |
| Nora: | So it was funny because, for him, it was like love at first sight kind of thing. And so, he had to, like sort of, wean me into what he already he had in his mind and sorta—and so, uh, the first few dates we had was all about talking about my background, what I wanted to do and if he was going to accept me like that. Because I told him I would never be put down again. I would always be my own woman. It would be a fifty-fifty marriage, you know, contribution financially— |

80

| | |
|---|---|
| Interviewer: | Was he divorced or had been married? |
| Nora: | No, he was—he had never been married. |
| Interviewer: | OK. |
| Nora: | Had no kids. And his thing was, he had already done all the single fun stuff (laughs), and he was ready to get married and have kids and all that kind of stuff. The only difference between my first husband and him was that he was very supportive, very supportive from day one of whatever it took to make me successful, to make me happy, he was going to do it. So kids could come in the picture, but that did not stop me from... |
| Interviewer: | So you agreed to have children, but you still wanted to work? |
| Nora: | Yes. |
| Interviewer: | And did you have other children? |
| Nora: | Yes, two more. |
| Interviewer: | Wow. |
| Nora: | So I had two more. |
| Interviewer: | And so how old were you when you married a second time? |
| Nora: | I was thirtyyyy... |
| Interviewer: | Thirty-something. |
| Nora: | It was in the thirties. Middle thirties. Probably thirty-five, thirty-six. Something like that. Because I had my second, I think, I was, like, thirtyyy-seven. And my fourth, I mean my third child, at thirty-seven and I think my last one at thirty-eight. So, it wasn't, you know— |
| Interviewer: | And you went to work right away? |
| Nora: | Yeah, pretty much! |

## THE STORY OF ST. ELMO'S COFFEE PUB (00:22:53)

| | |
|---|---|
| Interviewer: | So tell us how did this lovely place come to be. |
| Nora: | This lovely place came to be...I-I, through a friend of my husband, and this while I was still doing the candle thing. I was still working for Party Light. Um, they owned the Snuggery Cafe, which is now, which used to be where the Evening Star is now. And this was in the '80s. And it was his friend, best friend from childhood, they owned it. It was him and his wife that ran it. |
| Interviewer: | And was that a coffeehouse? |

| | |
|---|---|
| Nora: | No. That was a full-fledged restaurant. |
| Interviewer (overlapping): | Restaurant. |
| Nora: | And so, one night, uh, while my fourth child was, uh, she was born November, so this was, like, January, she gave me a call at home and she's [like], "Nora, would you like to help us down at the restaurant?" I said, "I've never done restaurant work before." She said, "Just do what you do best, which is being a great hostess. And that's what we want you to be is a hostess. So could you come down and help on just Saturday nights?" And that started the whole thing of my learning about restaurants. |
| Interviewer: | So you greeted people? |
| Nora: | Yes, I greeted people, I sat them down. |
| Interviewer (overlapping): | But you didn't stop there (laughs)/ |
| Nora: | Oh, no. |
| Interviewer: | You started learning the business. |
| Nora: | I started learning the business. And from there, then she says, "OK, you want to do some waitressing?" "Yes." So I did waitressing. And then a position opened in the bar. She says, "You want to try bartending?" "Yes, I'll try bartending." I probably would've stayed with them, but because it was family owned, there was no going up the ladder. They ran everything. They were managers, you know (laughs), um, they did everything. And so I really... and so, uh, the cook that left there and went to work for Bread and Chocolate called me up. He says, "There's a management position open at Bread and Chocolate. I think you'd be ideal." |
| Interviewer: | In Old Town? |
| Nora: | Yes. So I called, and they hired me and I became a manager of Bread and Chocolate. And I went to work at the King Street location. And they were just ready to revamp, so I was part of the team of, of renovation there. And, um, I worked for them for about three years. And all during that time, they didn't know it, but they were training me to open up St. Elmo's. Because when I left, I took all their forms, all their everything. I just scratched over Bread and Chocolate and put St. Elmo's Coffee Pub, literally. |
| Interviewer: | Where did the name come from? |

| | |
|---|---|
| Nora: | This is the St. Elmo's neighborhood, so that's number one. Number two, it's the patron saint of sailors. Alexandria is a port city. |
| Interviewer: | Ah. |
| Nora: | Everybody thinks of— |
| Interviewer: | The movie. |
| Nora: | *St. Elmo's Fire*, yes. The movie. But, no, it is all about neighborhood. And of course, um, I was, um, I want to backtrack a little bit because, prior to me finding this location, I was going to open up a flower shop because, in between doing Party, you know, Party Lights, I started to, I joined the garden club over in my community over in Arlington, which I'm still a member. That's like twenty-eight years being a member. I love flowers. And I learned enough that I thought I could open up a flower shop— |
| Interviewer: | So excuse me. When you married the second time, you moved to your current neighborhood in Arlington? Or—? |
| Nora: | Yes, yes. I've been in the same spot, in the same house, since I got married. |
| Interviewer (overlapping): | OK, OK. |
| Nora: | And, um, anyway, so what I did was I started a small wedding flower business out of my own home. And so I started doing wedding flowers. And I got my clients from working at the coffee—I mean, restaurant, talking to people. |
| Interviewer: | You got the wedding flowers from your own garden? |
| Nora: | No. Some, little bit. But most of them, you know, y-you purchase just like flower shops do. |
| Interviewer: | And then you just make them into...? |
| Nora: | Yeah, you know. Yeah, just like, you know, just like a floral arranger. You sit down with the client. "What do you want?" "What kind of flowers?" "Color?" You know, so I... it's some part consultation and then arran—I did the whole thing myself. |
| Interviewer: | And you were able to work from your home? |

Nora: Yes, I was able to work from my home because I had plenty of room to set up refrigeration and, you know, space to design and all that. So I did that for...in the meantime. Anyway, an opportunity opened up on Duke Street, and I don't know if you remember the little white house that used to put out, um, buckets of flowers. It's now a used car place, right before the shopping center where there's, um, tsk, um, let's see...past Generous George's. Remember Generous George's?

Interviewer: Yes (laughs), I live right there.

Nora: OK, so just part [of] Generous George's was this little white building—

Interviewer (overlapping): Right.

Nora: And it was a flower shop...

Interviewer: OK.

Nora: During that time. And those people owned another location, and they wanted to sell this one. So I got, you know, got together with them, and we interviewed. They loved me. They said yes, this would be a great, you know, thing. So I was going to take over with the option to purchase it. And I was ready to go and sign the papers when my good friend and my husband's good friend from college days, Scott Mitchell, called up and said, "Nora, I have this wonderful opportunity for you and me. We have to sit down." I said, "Oh, no, Scott! I'm going to—" He said, "No! Don't sign anything until you meet with me!" So immediately, I held that off for a day and met with Scott. He came and showed me the location.

Interviewer: This location?

Nora: This location. He said, "I just purchased this building, and I have an idea to open up a coffee shop." Bango! This is what, what I had already been planning, to open up some sort of restaurant on the avenue. And it was not a coffee shop. But it was going to be some kind of diner. I wanted to do some kind of New Jersey style, which is breakfast and lunch. That was going to be my thing on the avenue. So when he said that, I said, "Oh my God." Everything just came into place. And so, since he didn't have that knowledge and I did, then he became, he bought, he had just purchased the property. And so, um, then we just got together and made a business plan. We were going to be business partners, fifty-fifty. I would run it and he'd just be the support person.

| | |
|---|---|
| Interviewer: | And…did you…and you still planned to have it be a breakfast-lunch restaurant, more restaurant type of thing? |
| Nora: | No, we were going to make it a coffee shop. |
| Interviewer: | Oh, now you were going to do a coffee shop. |
| Nora: | Yeah. |
| Interviewer: | Alright. |
| Nora: | Yeah, a coffee shop because, uh, during this time, this was right before Starbucks became national. So then what we did was, since really Starbucks was the first coffee chain that was, um, serving gourmet coffee. To that point, all we had was 7-11, you know, dinky diner coffee. Sanka. |
| Interviewer: | Dunkin' Donuts. |
| Nora: | Dunkin' Donuts. That's—so Starbucks then raised the bar to what coffee should be. And so we followed that. |
| Interviewer: | Is there a Starbucks nearby? |
| Nora: | No, and there wasn't. And then what we did, we did a lot of research. Actually, St. Elmo's became my baby. From the day I met with Scott to the day that we opened was nine months. So exactly nine months, how you carry a baby, a child. So I saw that as, you know, there [were] steps every month. There was a lot of coffee-tasting all over. We went all over. We went to Seattle. You know, all these different roasters. We wanted to learn. We even met the founder of Starbucks. And, uh, you know, just read books and a lot, like I said, a lot of tastings. We learned a lot about coffee. And so we could then, uh, have the great vision of what we wanted to do. We wanted to be like Starbucks, but we felt that Starbucks did a lot of things that we didn't want to do. And one of them was, we wanted to be a community place. Like most restaurants, they believe that the model is flip tables, flip tables, flip tables. Starbucks is get them in (snaps), get them out (snaps), get them in (snaps), get them out (snaps). We wanted a place…because this is what I heard from my customers as a bartender, was, "We want a place where we can hang out like a bar but with no alcohol." |
| Interviewer: | With nice, comfy chairs. |
| Nora: | Exactly. With nice, comfy chairs, where everybody's welcome. Kids, dogs, blah, blah, blah. And so then, that's what our focus was. We were going to—so that's what our tagline is: "A community gathering place." And it has been since day one. Through the years, and it's just been, I say, the last four or five years, that they say St. Elmo's is Del Ray's living room. |

| | |
|---|---|
| Interviewer: | Wow. |
| Nora: | Because...when we opened that first year, from April when we opened to December, Mancini's then came in. Evening Star then came in. And all those places, guess where they did all their business dealings? At St. Elmo's was where they planned to open. And we were very welcoming because Del Ray was not Del Ray at that time. |
| Interviewer: | That's what I was going to ask you. I mean, I lived in Old Town. Not in Old Town, but about two miles west of Old Town. |
| Nora: | Right. Right. |

### DEL RAY BACK THEN (00:32:23)

| | |
|---|---|
| Interviewer: | And...but Del Ray has the reputation— |
| Nora: | It had a stigma. |
| Interviewer: | Of being a neighborhood now. |
| Nora: | But then it had the stigma of being the pit. If you talked to anybody that is my age and younger, they will tell you that all their parents used to say, "Don't you set foot in Del Ray." It was a really bad place. |
| Interviewer: | Bad like in dangerous? |
| Nora: | Dangerous, exactly. Because Del Ray, not like Old Town, went through the riots, racial riots, all that kind of stuff, where, you know, this was very diverse in racial. |
| Interviewer: | So what do you think started turning it around? And— |
| Nora: | Me! |
| Interviewer: | And don't be modest (laughs). |
| Nora: | (laughs) Me! They gave us credit, but we didn't set out to do that. Remember, the only reason we were here was because he bought this property, but because he worked here and I worked here, we knew who was here. We knew that these were the people who were going to support us. And they weren't bad people. They were good people, like him and I. And nobody else saw that. Because we did our research, when I did my research— |
| Interviewer: | Was he, your partner, was he a native Amer— |
| Nora: | Yes. |
| Interviewer: | Okay, I don't mean a Native American. I mean— |
| Nora: | Yes, yes. |
| Interviewer: | I mean, born in the U.S. |

| Nora: | Not just born in the U.S. but in Alexandria. |
|---|---|
| Interviewer: | OK. |
| Nora: | He's been, and his family's been, in Alexandria forever. And he knew (pause) the area. This is, when he finished college, this is where he started his business. He was a painting contractor. He, you know, this is where he started his business. He started buying little bungalows, fixing them up. After he started painting, he started that, you know. Where he'd go, "Oh, look. I can make more money doing this." So now he's a very successful developer. That's what he does. And he owns half of the avenue. |

## St. Elmo's Coffee Pub Today (00:34:12)

| Interviewer: | And he's still your partner? |
|---|---|
| Nora: | No, I bought him out, um, about ten years ago, in 2007. And, um, it was because he was really the, the mind of flipping. And so, he was ready to flip. So he says, "OK, so you going to buy me out?" And I say, "Sure," because it was just the two of us. He offered me the building, but at that time, I couldn't afford both the business and the building, which was the worst mistake I've ever made. Because if I would've owned my building, I would've been here forever. Unfortunately, I'm having problems right now. |
| Interviewer: | What kind? |
| Nora: | With my current landlord. |
| | (Silence.) |
| Interviewer: | Don't tell me St. Elmo's is in danger... |
| Nora: | Yes. |
| Interviewer: | Of not being here. |
| Nora: | Yes. And it's because, really, and, you know, I-I, uh, as being an, um, businessperson and knowing that people go into business just because of, you know, like me, I love it, for passion. Yes, I have built and I have raised a family and made my own job, pretty much. This is, this is my life. And I've been able to pay myself enough that I can send all my kids through college, you know, bought a house and supported myself through St. Elmo's. That's it. I'm not a millionaire. I don't have big, big, you know, bank accounts and stuff like that. Because that's all I wanted. |
| Interviewer: | Do you— |

| | |
|---|---|
| Nora: | But people see, because of the success of St. Elmo's, and they associated me with my partner, they always thought that I was a millionaire and I owned—believe me, when I talk to customers, "You shouldn't be complaining. You're a millionaire. You know this and this." I say, "No, Scott's not my husband. He was my partner. That's his business. This is my business." So I had to—but yet, it's perception. It's the perception that people see. It's just like they said, "Oh, you're making so much money." No. If I don't, if I wasn't busy on Saturday and Sunday, I wouldn't be able to carry the rest of the week (laughs) when it's not so busy. |
| Interviewer: | You are open seven days a week. |
| Nora: | Seven days a week, sixteen hours a day. |
| Interviewer: | And are you here? |
| Nora: | Uh, pretty much every day. |
| Interviewer: | And how much staff do you have? |
| Nora: | Right now I have thirteen, with a general manager, and he's the one that has been able to give me the opportunity to do this, so I can— |
| Interviewer: | I forgot. Now you're doing real estate now, too. |
| Nora: | Yeah, yup. |

## ON BEING AN IMMIGRANT (00:36:39)

| | |
|---|---|
| Interviewer: | So do you think that being an immigrant has in any way contributed to your drive? |
| Nora: | Yes, definitely, definitely. Not being afraid. I think most immigrants...and if you see the very successful ones, like, I can tell you, Hermán from Los Tíos. I mean, there's many of them. Rhoda Worku from Caboose. I—she was a friend of mine. I started her in that business. |
| Interviewer: | And being willing to start at the bottom, too. |
| Nora: | Yes. |
| Interviewer: | Yes. |

| | |
|---|---|
| Nora: | Not, not being—having that pride that you can't scrub floors. Because what's coming now are the people that, they'll buy a business and have people hired to do it, but they don't set foot in there. All they do is they do the collecting. To me, this is what has made St. Elmo's special is that my face is there. They see my sweeping. Just yesterday, one of my (laughs), two of my old-time customers, the minute they saw me, I was out there straightening tables. I came and sat, and they started laughing. They said, "Nora, you don't have to do that." I said, "Why not? I'm the owner. I want it a certain way, and I'm going to do it." |
| Interviewer: | Where do you think you would be if you had stayed in Cuba? |
| Nora: | Hmm…that's a question that I've never been asked, and I'm not sure where I would be, but I'm pretty sure that… you're born with a drive. And I followed in my father's footsteps. Not— |
| Interviewer: | He took, he took the really big risk, right? |
| Nora: | He took big risks. |
| Interviewer: | Because he wanted to— |
| Nora: | Yes. And my mom was very strong, but I never saw my mother as strong as my father. And again, it was because of that thing of keeping woman at home kind of mentality. Just like he tried to keep me, you know, at home. |
| Interviewer: | What about your siblings? Do they have the same drive? |
| Nora: | Yes, yes. Uh, my younger sister, not as much. |
| Interviewer: | She was born here, you said. |
| Nora: | Because she was born here. And she was spoiled because she was the last one. So it was a totally different mentality. But my brother, yes. My brother has his own business also. |
| Interviewer: | What is he doing? |
| Nora: | Right now, he's retired. He retired early. He was a pipe fitter in the union, so you know, that's a pretty good job. And, so, he was in New Jersey just till he retired. He's in Florida now. But he also, before, he also had a business. He owned a bar in New Jersey, which his wife and him ran. His wife pretty much ran it, you know, but they were both owners. |

## Future Plans (00:39:34)

| | |
|---|---|
| Interviewer: | I guess the last question would be, if the unthinkable happens and you do have to lose St. Elmo's, what will you do next? |
| Nora: | Well, I am planning on continuing with Coldwell Banker. Um, they're...they give me the freedom again. I'm pretty sure all the companies would, but they've been very supportive with education. |
| Interviewer: | You mean in terms of your training? |
| Nora: | Yes, yes, yes. And so, I'm a learner. I don't stop learning. Everyday I— |
| Interviewer: | Sounds like you're never going to retire. |
| Nora: | Eh, no, no. |
| Interviewer: | No. |
| Nora: | And that wasn't my plan for St. Elmo's, either. I was hoping that I could keep it forever. Unfortunately, none of my four kids wanted it because they saw how much work it is, so they're—I gave them wings and they flew. And they are all over the place, doing their own thing. So I never said to them, "You must stay in the family business" because I didn't want that restriction put on me, so I'm not going to put that on them. (Pauses.) My, uh, youngest son has been with me for fourteen years, which is amazing. |
| Interviewer: | With you at St. Elmo's? |
| Nora: | At St. Elmo's. He's the only one of the three that stuck with me, but he's leaving me next month. He's going to LA. He's spreading his wings, finally. |
| Interviewer: | And where are the other children? |
| Nora: | Uh, there's another one in LA, in the film industry. |
| Interviewer: | Can't get much farther. |
| Nora: | Nope. And another one that was in Alaska, but he just moved to Oregon. |
| Interviewer (overlapping): | Oh, my goodness. |

Nora:      And he has a job, uh, traveling, so he's in South America, has been in South America for about five weeks with his job. And then I do have a...um, the...my oldest daughter, she's in North Carolina, so at least she's on the East Coast. She's the one who has three children, out of four. So I have four grandchildren, all boys. So she has three and my oldest has one, the one that lives in Oregon. And she is, uh, into education. She's not like me, you know. She's not an upfront person. She likes working in the background, so she's an administrator in education, preschool.

Interviewer:      And would you ever think of leaving Northern Virginia?

Nora:      (Pause.) It's going to be after this winter. It's going to be kind of hard, but Florida is calling, so...you know, we'll see. My husband's not ready to retire, so I'm probably going to be around here for a while and, um, I'm not going away.

Interviewer:      Well, speaking on behalf of probably everybody I know, I hope St. Elmo's stays right where it is. And, Nora, thank you so much for taking the time to talk.

Nora:      Well, I hope, it was a good one. Thank you so much.

*La Rotunda de los Jaliscienses Ilustres* is a monument that pays tribute to notable Jaliscan figures from various industries in Guadalajara, Mexico. *Christine Stoddard.*

*La Minerva* is a monument in Guadalajara, Mexico, recognizing eighteen notable figures. Its frontal engraving reads, "Justice, wisdom, and strength to guard this loyal city." *Christine Stoddard.*

Community members convene at a round-up of Virginia Catholic Advocacy Day 2015 topics, which included asking state legislators to take a pro-immigration stance. *Christine Stoddard.*

# 6
# ARTS AND MEDIA

*It is not true that people stop pursuing dreams because they grow old,*
*they grow old because they stop pursuing dreams.*
—*Gabriel García Márquez*

The elegant 2300 Club glowed only a few yards before me. That sliver of Grace Street in Richmond's historic Church Hill looked particularly charming at night. Even the club's hedges seemed beautiful and mysterious in the lamplight. A line of ladies in LBDs (that's little black dress for the uninitiated) and men in sharp suits started removing their evening coats as they approached the front door of the brick Civil War–era row house. It was a brochure photograph waiting to happen. I was excited to enter the handsome house and meet some of the creative, passionate people whose efforts have made the Latin Ballet of Virginia a reality since 1997.

It was the evening of February 5, 2011, and the Latin Ballet was hosting its Winter Rumba to help support its numerous shows and educational initiatives. It was a festive social affair, with savory food, dance demonstrations and a silent auction. The moment I stepped into the 2300 Club, gentlemen greeted me and pointed out the coat closets. Winter Rumba was so popular that the closets were full when I arrived only twenty minutes after the event began!

The Latin Ballet is the commonwealth's leading Hispanic dance company. Embracing everything from classical ballet to tango and flamenco, the Latin Ballet has performed and educated dance lovers across the state. Its ten professional dancers and nine professional musicians have also showcased their

talents in North Carolina; Washington, DC; and parts of Latin America. The company also manages a junior company, comprising twenty-five students. Make a Wish Foundation, the Children's Hospital and children in Cartagena, Colombia and Zacatecas, Mexico, are just some of the organizations and individuals who have benefited from the Latin Ballet's productions.

Non-Hispanics tend to associate Hispanic creative expression with music, particularly more festive styles conducive to dancing. While music is an important part of Spanish and Latin American cultures (as evidenced by the Latin Ballet), it is not the only form of art and media. The visual arts, theater, literary arts, newspapers, film and other modes of communication have a place, too.

## VISUAL ART

Several Virginia art museums contain Spanish and Latin American art in their permanent collections.

Richmond's Virginia Museum of Fine Arts (VMFA) most notably contains works by Pablo Picasso and Francisco de Goya in its permanent collection. These include Picasso's *Still Life (Wineglass and Newspaper)* (1914), oil and sand on canvas, and *Woman with Kerchief* (1906), gouache and charcoal on paper, and Goya's *General Nicolas Philippe Guye* (1810), oil on canvas. Its largest single collection related to Latino art is its Ancient American Art collection. In addition to its North American artifacts, this collection features Pre-Columbian and early Central and South American art produced before the indigenous peoples' contact with Europeans. Much of the work is functional, with an ample range of ceramics and textiles in the mix. Highlights include a Peruvian Nazca–style bowl decorated with trophy heads (AD 100–400) and a Mayan mosaic mask (600–900), among other artifacts.

Dr. Lee Anne Hurt Chesterfield is the VMFA's first curator for Ancient American Art. According to her official VMFA biography, she is an expert in ancient South American art. She received her PhD in art history from Virginia Commonwealth University, where she dedicated herself to a dissertation entitled, "The Huacas of Machu Picchu: Inca Stations for the Communion Between Humanity and Nature." She assumed her current position as assistant curator of ancient American art in 2006, opening the VMFA's first permanent Pre-Columbian and Native American galleries in 2010. She also serves as the director for museum planning and board relations.

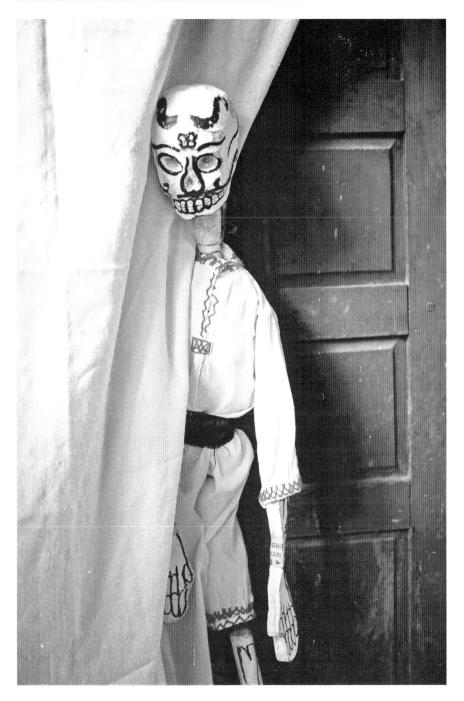

Latin American folk art has been influenced by a blend of Spanish, Portuguese, African and indigenous cultures. *Helen Stoddard.*

Yet most of the Hispanic fine artists represented in the VMFA's permanent collection, including Picasso and Goya, are Spanish. Take, for instance, works by Juan Gris (1887–1927). Though he spent much of his life in France, the cubist painter and sculptor was born José Victoriano González-Pérez in Madrid. His mixed-media piece *Carafe, Glass, and Packet of Tobacco* (1914) depicts what its title implies, albeit in a cubist fashion. Squint and you might detect the pasted paper, gouache and charcoal on canvas.

There also are multiple examples of Spanish subjects in VMFA's permanent collection, even if they were not painted by Spanish artists. One example is *Spanish Girl of Madrid* (1908) by Robert Henri (1865–1929), an American artist. This oil on canvas was purchased for the VMFA by the J. Harwood and Louise B. Cochrane Fund for American Art. Another is *A Family of Spanish Poachers* (circa 1870s) by Gustave Doré (1832–1883), a French artist.

The Virginia Museum of Fine Arts has had several exhibits of work by Hispanic and Latino artists as well. The most famous was "Picasso: Masterpieces from the Musée National Picasso, Paris" in 2011. Picasso's work also appeared in a VMFA group exhibition, "Matisse, Picasso, and Modern Art in Paris" in 2010.

Though the Virginia Museum of Fine Arts is the largest fine arts museum in the state, it is not the only one. The Chrysler Museum of Art in Norfolk, the Virginia Museum of Contemporary Art and the Taubmann Museum are the state's other large, independent art museums. A few Virginia colleges and universities also run art museums. Here are some of the museums' standout shows, artists and collections:

The Chrysler Museum of Art in Norfolk includes numerous works from Latin American artists in its permanent collection. The Chrysler showed "Airborne" by Mexican Canadian artist Rafael Lozano-Hemmer in 2013.

The Virginia Museum of Contemporary Art in Virginia Beach showed the work of Spanish artist Paloma Muñoz in 2012 and the work of Brazilian artist Vik Muniz in 2014.

The Taubmann Museum in Roanoke showed "Between Two Worlds: Annette Nancarrow in Mexico and America" in 2015. "Vik Muniz: Poetics of Perception" and "From Picasso to Magritte: European Masters" also showed at the Taubman.

The Fralin Museum of Art at the University of Virginia in Charlottesville has Pre-Columbian art in its collection. These pieces are part of the Object Study Gallery, which displays about 140 ancient and indigenous cultural

objects. In a statement, Elizabeth Hutton Turner, former vice-provost for the art at UVA, said:

> *The gallery's opening* [in 2012] *signals a new programmatic engagement at the museum with the research and teaching mission of the university community. The university is pleased to offer our community this exciting opportunity for engagement with beautiful and enduring tokens of culture that engage the senses and mark the passage of time.*

In the summer of 2012, the Franlin hosted the exhibition "Emilio Sánchez: Cityscapes." Cuban American artist Emilio Sánchez (1921–1999) is famous for rendering urban scenes. Curated by Jennifer Farrell, the exhibition featured forty-four works—watercolors, oils, lithographs and drawings—gifted by the Emilio Sánchez Foundation. The Fralin also hosted "Matisse, Picasso, and Modern Art in Paris" in the spring of 2009. In the fall of 2005, the Fralin hosted "Mi Cuerpo, Mi País: Cuban Art Today," which showed works of personal and national identity by contemporary Cuban artists. In 2001, it showed the photography of Cuban-born artist Abelardo Morell in "Abelardo Morell and the Camera Eye." That same year, it showed "The Art of John Dos Passos." The American novelist, whose father was half Portuguese, pursued a parallel career as a visual artist.

MacCallum More Museum & Gardens in Chase City is home to various Spanish and Mexican artworks. Commander William Henry Hudgins was a world traveler and often brought statuary and other artifacts from his journeys to the elaborate garden his mother, Lucy Morton Hudgins, forged in Mecklenburg County. He brought twelve Granada lions, which resemble the lions of the Alhambra, from Spain. The lions surround a fountain located near the Spanish cloister.

While the VMFA, the VMOCA, the Taubman Museum and other longstanding state and university institutions have programmed exhibitions featuring Hispanic and Latino artists from time to time, the Old Dominion has had only one organization exclusively devoted to Latino art, culture and even social issues. That was the now-defunct Virginia Center for Latin American Art (VACLAA), a community arts organization founded by husband-and-wife team Spencer Turner and Eva Rocha in January 2012.

By day, 401 West Broad Street is home to Moore's Auto Body and Paint Shop. But on every First Friday Artwalk since April 2013 until the nonprofit's closure, the lot that was usually full of cars became home to Galería Movimiento, VACLAA's converted school bus and mobile gallery.

Turner and Rocha painted the formerly yellow bus a greenish brown, adding the center's initials in salmon, orange, mint and canary on the side. The vehicle saw countless hours of do-it-yourself tinkering by the couples' hands, including the rewiring of its lights to better illuminate the works on display. Rocha, a Brazilian immigrant, and Turner, a native Richmonder, shed light on cultural creations that once tiptoed in Richmond's shadows.

It all began in October 2011, when Rocha was working at the VMFA for the first Latin American Family Day and she began to hear stories from local Latino artists and artisans discouraged by their lack of acceptance in local galleries. She and her husband promised to investigate, and that's when they began to develop their bus idea. Over the next year or so, Rocha soon noticed fewer artists were hiding their Latin heritage, particularly at the VMFA's second Latin American Family Day, which drew a huge crowd.

Turner and Rocha introduced multiple different Latino artists and curators to the Richmond public. One such artist, Sandra P. Cornejo, a Salvadoran American Virginia Commonwealth University alumna, was the 2012 winner of the Evelia Gonzalez Port Latino Art in Virginia fellowship. Her original painting was the first to be added to a new collection of Virginia Hispanic work at the Library of Virginia. This was one of the VACLAA's many successes during its short reign. Unfortunately, the organization closed in December 2014, citing a lack of funding.

## THEATER

Teatro de la Luna, the state's only Spanish-English bilingual theater company, calls Arlington its home. While the administrative headquarters are located in Washington, DC, the company produces many of its shows at the Gunston Arts Center in Arlington. The Arlandria neighborhood has been Teatro de la Luna's creative home since the company was founded by husband-and-wife team Mario Marcel, now seventy-seven, and Nucky Walder, now sixty-seven, in 1991. The company produces an international Hispanic theater festival, a children's theatre festival, a harps festival, a tango cabaret and a poetry marathon every year. It also produces at least two stage plays every season. But its most impressive endeavor is

its annual international Hispanic theater festival. Every October, Spanish-language theater companies travel from far-flung places, including Uruguay, Chile, Spain and Argentina, to perform in Teatro de la Luna's International Festival of Hispanic Theater in honor of National Hispanic Heritage Month.

## LITERARY ARTS

Rei Berroa, a professor at George Mason University in Fairfax, is a poet and literary translator originally from the Dominican Republic. He is the head of GMU's Spanish program, which publishes the *Hispanic Culture Review*. Berroa also collaborates with the aforementioned Teatro de la Luna, translating stage plays for projected surtitles, coordinating the organization's poetry marathon and more.

The *Hispanic Culture Review* released its twenty-fifth-anniversary edition during the 2013–14 academic year. The bilingual academic journal publishes creative and scholarly work, including essays, short fiction, photography and visual art from the GMU community and beyond.

Here is an excerpt from the journal's mission statement:

> *The purpose of the annual publication is to contribute to GMU's multiculturalism by creating cultural links between the university's community, persons, and institutions involved in the creation and diffusion of Hispanic culture in the United States, Latin America, and other nations where Spanish is spoken.*

A few anthologies have sprung from Teatro de la Luna's poetry marathon, each one edited by Berroa. For the sake of having them on the historical record before all books are burned, here's their authorial lineup:

*Cauteloso Engaño del Sentido* is the name of the anthology released in honor of the 2006 and 2007 poetry marathons. The book identifies the XVI Teatro de la Luna Poetry Marathon as having taken place at the Library of Congress and at Teatro de la Luna's administrative offices in Washington, DC, as well as Edgar Allan Poe's tomb in Baltimore, Maryland. The fifteenth Teatro de la Luna Poetry Marathon took place on April 13–15, 2007, to commemorate the 800th anniversary of the

publication of "Cantar de Mío Cid," or "The Song of My Cid," the oldest Spanish-language epic poem.

The following poets have work represented in *Cauteloso Engaño del Sentido*: Ivaán Oñate (Ecuadoran), Renée Ferrer (Paraguayan), Fernando Operé (Spanish), Mario Bojóquez (Mexican), Ariel Montoya (Nicaraguan), Carmen Valle (Puerto Rican), Gladys Ilarregui (Argentinian), Silvia Tandeciarz (Argentinian), Eduardo Langagne (Mexican), Ivón Gordon Vailakis (Ecuadoran), Manuel Cortés-Casteñeda (Colombian), José Mármol (Dominican), Juan Manuel Rodríguez Tobal (Spanish), Soledad Alvarez (Dominican), Alfredo Villanueva-Collado (Puerto Rican) and Carolyn Kretyer-Foronda (Virginian).

*Que no Cesen Rumores* anthologizes the poems performed at the 2010 poetry marathon. The book's title page states that the eighteenth Teatro de la Luna Poetry Marathon took place at the Library of Congress and at Teatro de la Luna's administrative offices in Washington, DC, on June 4–6, 2010. The following poets have work represented in *Que no Cesen Rumores*: Tina Escaja (Spanish), Leticia Herrera (Mexican), Aida Toledo (Guatemalan), Zulema Morer (Argentinian), Raúl Castillo Soto (Puerto Rican), Fernando Cabrera (Dominican) and Mirarim Ventura (Dominican-American).

But GMU, Berroa and Teatro de la Luna are not the only ones keeping Spanish-language literary arts alive in Virginia. Gival Press (pronounced zhi-val) is an independent press based in Arlington that publishes work in English, Spanish and French. Robert Giron, previously an editor at the *Potomac Review*, founded Gival Press in 1998 after unsuccessfully attempting to sell a translation of poetry by Mexican writer Jesus Gardea.

The press runs the Arlington Literary Journal, an online literary journal, and produces many books of interest to the LGBTQ community. Its books have won the Independent Publisher Book Award, the New York Book Festival Award, the Los Angeles Book Festival Award, the Appalachian Writers Association Book of the Year Award for Fiction and other accolades.

The University of Virginia in Charlottesville also has a proud heritage of honoring Spanish literature. The department website features this 1787 quote from Thomas Jefferson, founder of UVA: "Spanish. Bestow great attention on this and endeavor to acquire an accurate knowledge of it. Our future connection with Spain and Spanish America will render that language a valuable acquisition." In 2010, UVA's graduate Spanish program was ranked one of the top in the United States by the National Research Council.

## Newspapers and Online Media

The *Washington Post* produces *El Tiempo Latino*, a weekly Spanish newspaper that is distributed for free throughout the Washington, DC metropolitan area, including Northern Virginia. Headquartered in Silver Spring, Maryland, *Washington Hispanic* is another Spanish-language newspaper available in the Washington metro area. Established in 1994 by media executive Johnny A. Yataco, the newspaper has a circulation of more than 100,000.

Other Hispanic newspapers found in Virginia include *Tidewater Hispanic News*, *La Nación*, *El Comercio*, *El Pregonero*, *Washington Voz*, *Latin Hope/Mexican Fiesta*, *Tiempos Del Mundo*, *Los Tiempos*, *La Voz Hispana de Richmond* and *La Voz Latina de Roanoke*.

As of this book's printing, most of the regional Spanish-language and bilingual web media are tied to a print or television brand. There is no stand-alone Latino news website for Virginia. Compare that to the website LatinoCalifornia.com, for instance, which focuses on socially minded alternative journalism, or ElHispanoNews.com in Dallas, Texas.

## Television and Radio

Most of the Spanish-language television content broadcast on Virginia stations is not produced in Virginia. Telemundo, owned by NBCUniversal Television Group, is headquartered in Hialeah, Florida, which is part of Greater Miami. The network shoots most of its news and soap operas there. The Washington Telemundo affiliate, WZDC-CD (channel 25), is located in Arlington, with its transmitter in Northeast DC. The Richmond affiliate, WZTD (channel 45), shares facilities with WCVE and WCVW, the Richmond and Charlottesville PBS affiliates.

Based on Constitution Avenue, Washington's Univision affiliate, WFDC (channel 14), broadcasts in Northern Virginia. Regionally, it is known for *Buenos Dias DC*, the first Spanish-language morning news program in the Washington metro area. The landmark show's tagline translates to: "The voice of our community that day-by-day works toward a better country." Released in September 2013 and directed by Sara Suárez, the show is hosted by Silvana Quiroz and Nestor Bravo. Guests have ranged from Venezuelan actor Néstor Bravo to Teatro de la Luna

musician Jason Cerda. Regular segments include "Nuestros Barrios" ("Our Neighborhoods"), "La Policía y Tú" ("The Police and You"), "Tu Propia Empresa" ("Your Business") and others.

Based in Arlington, WETA, the PBS station of Greater Washington, was one of the producers of *Latino Americans*, a six-hour documentary that premiered in 2013 and featured one hundred Latinos from five hundred years of history. Other producers included Bosch and Co., Inc.; Latino Public Broadcasting; and Independent Television Service. Jeff Beiber and Dalton Delan were WETA's executive producers on the project.

Abilio James Acosta, simply known as Jim Acosta on screen, is best known as CNN's senior White House correspondent. What's lesser know is that he is a Cuban American from Annandale who graduated from James Madison University in Harrisonburg in 1993.

Most of the Spanish-language radio stations in Virginia are religious. There are two mainstream Spanish radio stations based in Maryland whose broadcasts reach Northern Virginia: La Nueva (87.7 FM) in Silver Spring and El Zol (107.9) in College Park. Other Spanish-language radio stations include:

• WBTK (1380 AM), Richmond, Mount Rich Media, Spanish Contemporary Christian
  • WFAL (96.9 FM), Nassawadox, Hispanic Target Media
  • WJEV-LP (97.7 FM), Dale City, Ministerio De Vida
  • WRJR (670 AM), Claremont, Iglesia Nueva Vida of High Point
  • WTNT (730 AM), Alexandria, Metro Radio, Inc.
  • WVNZ (1320 AM), Richmond, Davidson Media Station
  • WVXX (1050 AM), Norfolk, Hindlin Broadcasting
  • WPFW (89.3 FM), Washington, D.C. Latino Media Collective

One of Hispanic Virginia's most notable radio personalities is Pedro Biaggi, a morning host on El Zol, a CBS station. He helms a weekday morning show called *Pedro Biaggi en la Mañana*.

## SPORTS

Soccer far outranks other sports among Virginia's Hispanics and Latinos. Popular leagues include the Arlington Bolivian Soccer League, the Alexandria Soccer League and Liga INCOPEA. Arlington Bolivian Soccer League president Félix Sandoval claims that up to three thousand people come out to watch or play every Sunday in South Arlington.

*Above*: Bull-fighting is a form of entertainment practiced in Spain and several Latin American countries but is illegal in Virginia. *Library of Congress.*

*Right*: Soccer is widely popular among Virginia's Hispanic and Latino immigrants. The state's USL Professional Division teams include the Northern Virginia Royals and the Richmond Kickers. *Library of Congress.*

Certain controversial sports associated with Latin cultures, such as bull and cock fighting, are not legal in Virginia or the rest of the United States.

7

# RELIGIOUS LIFE

*We are not Hispanic Catholic. We are Catholic Hispanic. The most important*
[part of our identity] *is our faith* [not our country of origin].
—*Antonio Alcalá, consecrated layman at Stabat Mater in McLean*

The influence of the Roman Catholic Church on Latin American thought, culture and everyday life cannot be understated. When the Spanish conquistadores arrived in the Americas, they brought—and imposed—their religion on the Amerindians. Hispanic immigrants continue the liturgical and cultural legacy of Latin American Catholicism in Virginia.

According to the Pew Research Center, 55 percent of adult Latinos identify themselves as Catholics, down from 67 percent in 2010. Approximately 16 percent self-identify as evangelical Protestants, with 5 percent saying they are mainline Protestants. Of Hispanic groups, Mexicans and Dominicans are most likely to consider themselves Catholic, while Salvadorans are more likely to identify as evangelical Protestants than Mexicans, Dominicans and Cubans.

## ROMAN CATHOLICISM

Virginia was once notorious for its anti-Catholic sentiments, driving Catholics to found the state of Maryland and seek refuge there. For many years, the Diocese of Richmond was the only Roman Catholic diocese

*Above*: Catholic pilgrims crowd a marketplace in Paita, Peru. *Christine Stoddard.*

*Left*: Tired pilgrims rest after a long trek to Paita, Peru. *Christine Stoddard.*

in the commonwealth. Then in 1968, the Diocese of Arlington was founded. Today, it encompasses Northern Virginia, from Front Royal in the west to Kilmarnock in the east. Richmond, meanwhile, encompasses the rest of the state.

Arlington bishop Paul S. Loverde established the Spanish Apostolate and the Office of Multicultural Ministries. The Spanish Apostolate serves Spanish-speaking communities, while the Office of Multicultural Ministries serves any other immigrant community seeking help with translation, immigration and cultural resources. This includes Vietnamese, Brazilian, Ghanian and other communities.

A man rests on a bench outside a church in a small town in Jalisco, Mexico. *Christine Stoddard.*

Father José Eugenio Hoyos, a priest hailing from Colombia, has led Arlington's Spanish Apostolate for many years. He writes a weekly column for the *Arlington Catholic Herald*, the official newspaper for the Diocese of Arlington. His column appears on the Spanish page, which features local news for the Hispanic Catholic community, as well as stories distributed by the Catholic News Service in Washington, DC.

Several Arlington parishes celebrate Spanish-language Mass. This includes All Saints in Manassas, St. James in Falls Church, St. Charles Borromeo in Arlington, Queen of Apostles in Alexandria and Good Shepherd in Mount Vernon, as well as others.

## THE CRISIS IN LATINO VOCATIONS

Only 15 percent of new priests ordained nationwide in 2014 were Hispanic, compared to 67 percent white, 11 percent Asian/Pacific Islander and 4 percent African/African American. Less than 5 percent of new Hispanic priests are US-born Latinos. With an ever-growing Hispanic Catholic population, those numbers do not match who is sitting in the pews. Nationally, Hispanics

make up 38 percent of all Catholics compared to 54 percent whites. Yet Hispanic men, by and large, are not discerning the priesthood.

"We need to focus on the people the priests are standing in front of," said Father Joel D. Jaffe, director of the Arlington Office of Vocations, in a 2014 interview.

Nearly 60 percent of the Hispanics living in the United States, or thirty million people, are estimated to be Catholic, with about sixteen million born in the United States and fourteen million foreign born.

CARA numbers indicate that about 69 percent of the US parishes known to serve specific racial, ethnic, cultural or linguistic communities cater to the Hispanic community. In the Arlington Diocese, the Hispanic community numbers about 222,000 compared to 263,000 non-Hispanic whites.

The question is not so much whether an effort is being made to serve the Hispanic community; rather, it is how these efforts should be concentrated.

Father Jaffe believes that one cause for the shortage in Hispanic vocations is that there simply is "not a strong enough emphasis on vocational discernment." He also pointed to the prevalence of Spanish-speaking Anglo-American and foreign-born priests serving US Hispanic communities.

"Because there are a lot of foreign-born priests," Father Jaffe said, "[Hispanic] children think [priests] always come from elsewhere." He explained that Hispanic boys and men might have trouble identifying with priests hailing from another culture. Even if the priests are Hispanic, they are more likely to have been born in Latin America or Spain than the in the United States. That distinction makes it more difficult for US-born Hispanics to envision themselves in the same position of leadership, Father Jaffe said.

"How do you imagine a priest like you if you don't see [priests like you] represented?" Father Jaffe asked.

Father Jaffe said that since Hispanic culture emphasizes family, there is a big expectation for young men to get married and have children.

"Plus, there's the whole idea of machismo and how becoming a priest is not considered a macho thing to do," he added.

Many Hispanic immigrants may plan to stay in the United States for a short period, working seasonal or otherwise temporary jobs to send money back home to their families in Latin America. Father Jaffe explained that these short-term plans mean that such men "are not invested in the diocese."

Then there is the matter of language. Father Jaffe and his assistant, Anne-Marie Minnis, both speak Spanish. They answer the phones in Spanish, write e-mails in Spanish and hold meetings in Spanish. They also produce a quarterly bulletin about local vocations news in English and Spanish.

"I knew the people needed a priest they could call their own, who cared for them and who could speak their language," wrote Father Jaffe in his November 2014 bulletin letter, "Shepherds Needed for Hispanic Communities."

But this is not just a language issue. Approximately 70 percent of all US Hispanics, Catholic or otherwise, are not immigrants; they are US born and English speaking. The US Conference of Catholic Bishops (USCCB) cites education and financial constraints as central challenges to discerning Hispanic vocations.

Studies show that men are at least six times more likely to consider the seminary if they attended a Catholic high school. Only 3 percent of US Hispanics attend a Catholic school.

While the cost of Catholic high school may be a burden to some families, the cost of a seminarian education is much greater, ranging from $33,000 to $40,000 per seminarian. In 2011, Laura Coleman and her husband, Bob, of Clifton started Arlington's seminarian education fund, which supports funding efforts "for the seminarians already committed to the diocese."

According to the USCCB, other factors that influence a man, regardless of race or ethnicity, to "seriously consider" a vocation are all "relational": participating in a parish youth group, receiving personal encouragement and personally knowing a priest or seminarian.

Currently, the Diocese of Arlington has two Hispanic seminarians: Raymel de los Santos, twenty-five, of the Dominican Republic, and Mauricio Portillo, twenty-eight, of El Salvador. Father Mauricio Pineda, also of El Salvador, was ordained in June 2014. He now serves as a parochial vicar at All Saints in Manassas.

Seminarian de los Santos, whose home parish is Queen of Apostles in Alexandria, studies at Pontifical College Josephinum. He credits "the great example of a priest" for influencing his decision to answer God's call.

"[The priest's] love for Christ, for the church and for his neighbors awakened in me the desire of becoming a priest," de los Santos said. "Furthermore, being an active member in my parish helped me to realize that this is the way I want to live my life, giving all I am for God's people."

Seminarian Portillo said praying every day for God to show him his vocation, seeing young people struggling with their faith and meeting priests "who live with a great joy in their vocation" were his reasons for pursuing the priesthood.

Portillo is now studying at the seminary Hogar Sacerdotal Padre Laforet and the Universidad Eclesiástica San Dámaso in Spain, thanks to Arlington's new pilot program for native Spanish-speaking seminarians. Father Jaffe

described San Dámaso as the best ecclesiastical institution in the Spanish-speaking world, saying that its rigorous entrance exam requires six to eight weeks of preparation. Portillo is the first participant in the pilot program between Arlington and San Dámaso.

Father Pineda had more than the hurdle of language on his path to the priesthood; he also had the hurdle of religion. Growing up in Cojutepeque, El Salvador, Father Pineda was baptized Catholic but worshiped with Seventh-day Adventist neighbors. It wasn't until he was fifteen that a few Catholic friends persuaded him to go to a meeting for Catholic charismatic youth. His childhood dreams of becoming a Seventh-day Adventist pastor were replaced with becoming a Catholic priest.

When he arrived in the United States at age eighteen, he spoke no English. He lived in Miami and Northern Virginia, working in construction with the hope of returning to El Salvador. But then he became involved with Stabat Mater, a secular Marian institute in McLean. Father Pineda began praying the rosary and going to Mass daily. In 2005, he met with Father Brian G. Bashista, then-diocesan vocations director, to discuss his desire to enter the priesthood. Though Father Bashista said Father Pineda had to improve his English to succeed, he encouraged him to apply to St. Charles Borromeo Seminary in Wynnewood, Pennsylvania. After studying English there for a year, Father Pineda went to Mount St. Mary's Seminary in Emmitsburg, Maryland.

Even if the educational, financial and language needs are being met, the cultural barrier to discerning Hispanic vocations remains.

Father John G. Guthrie, associate director for the Secretariat of Clergy, Consecrated Life and Vocations at USCCB, said that in some cultures, making eye contact when speaking to someone is the social norm. In others, such behavior is considered disrespectful. A parish may offer a Spanish Mass, but if Hispanic cultural practices are not understood and respected, that can cause discomfort and even animosity that would turn a man off to the priesthood.

In a USCCB webinar called "Best Practices for Multicultural Parishes," Bishop Daniel Flores, chairman of cultural diversity in the church, said, "The differences between cultures are very rich but can be a challenge. But that's not new; that's as old as the Gospel. Catholicism is a house that's meant to be big enough for all the cultures of the world."

Alejandro Aguilera-Titus, assistant director of Hispanic affairs at the USCCB, also appeared on the webinar and said that one way to make Hispanics and other ethnic groups feel included in the life of the church is to "set judgment aside about [accents]."

Father Guthrie explained that cultural differences can persist in more serious ways, such as in the case of psychological evaluations for seminary admissions.

"Some [psychological] tests are objective, but others are more culturally bound," he said. Cultural misinterpretations in psychological tests may influence whether or not a man is offered admission to a seminary.

Nationwide, various organizations are working to help Hispanics discern vocations. That help is becoming more and more available in person, in print and online.

One such initiative is *¡Oye!* magazine, published by Claretian Publications. Established in 2004, the Chicago-based magazine reaches about 100,000 young Hispanic Catholics throughout the United States. According to its mission statement, *¡Oye!* urges "young people to consider the ways in which they might be called, whether they be in a lay commitment, marriage and Christian family life, or the priesthood or religious life."

Organized prayer groups and retreats, some designed specifically for Hispanic men or more general prayer groups, such as the St. Thérèse Vocation Society, put Hispanic vocations on the agenda.

Every year, the first week in November is National Vocation Awareness Week, where Catholics are encouraged to invite at least one person to consider a vocation to priesthood or consecrated life. To support this effort, the Office of Vocations and the Spanish Apostolate both printed the prayer for vocations in their latest bulletins. Currently, more than one hundred men and women are in formation for priesthood or religious life in the Arlington Diocese.

"Continuing to bring priests from outside the United States to serve the United States is not really helping," said Father Jaffe. "We need vocations from Hispanic communities to serve Hispanic communities."

## Church Inclusivity Initiatives

As the Arlington Diocese becomes increasingly diverse, the Office of Multicultural Ministries and the Spanish Apostolate aim to support various cultural communities that practice their Catholic faith according to their unique liturgical traditions.

Though the Spanish Apostolate, which offers assistance to the Hispanic and Latino communities, has existed since 1974, the Office of Multicultural Ministries is much newer. The office was established under

the leadership of Arlington bishop Paul S. Loverde in 2004 after a survey of the diocese revealed a growing number of Catholic ethnic groups in the region.

"The office is here to shape, lead and guide the exponential growth of each and every cultural voice in our diverse diocese," said Corinne Monogue, director since 2009. Monogue began serving the office as its program assistant under Father Richard Mullins in 2005.

Multicultural Ministries helps and collaborates with the following communities: Asian and Pacific Islanders (Vietnamese, Korean, Indian, Chinese, Samoan and Filipino), African American, African (Eritrean, Ethiopian, Cameroonian, Ugandan and Ghanaian), European (German, Italian, Polish, Spanish, Irish, Portuguese and French), South American (Brazilian) and migrant (Haitian and Caribbean).

Every March, the diocese celebrates a Gaelic Mass. Additional Masses and prayer groups are celebrated and observed in Portuguese, French and Polish when possible.

Monogue said that the diocese has witnessed a huge growth in its Asian and Pacific Islander communities, while the Brazilian community, although comparatively small, remains committed.

At this time, more than thirty of the diocese's sixty-nine parishes offer Spanish-language Masses. All sacraments and religious education classes also are available in Spanish.

The Spanish Apostolate, led by Father José E. Hoyos, a Colombian priest with a strong, charismatic following, offers various Spanish-language events throughout the year. These range from quinceañera retreats for teenage girls to an annual talent show for all ages, with a special emphasis on positive outlets for youth.

"The Gospel of Christ reminds us that all human beings are the sons and daughters of God," wrote Father Hoyos in the Spanish-language blog padrehoyos.blogspot.com. "We belong to this great family redeemed by Christ and we are called to share the suffering of others."

Father Hoyos has served the diocese since 1988 and assumed the role of Spanish Apostolate director in 2005. He regularly celebrates healing Masses and maintains active Twitter and Facebook accounts.

"We want to create a welcoming home where communities feel comfortable with expressing their cultural identities, deepening their faith and carrying out their Catholic traditions," said Monogue.

One of the events organized by Arlington Diocese's Office of Multicultural Affairs is the Multicultural Choral Concert.

"[Catholic music] is steeped in tradition but sung in different languages," said Monogue. "Why not make it easily available to share with others in the diocese?"

The choir members performing at Arlington's Multicultural Choral Concert agree that the evening will be about education, faith and unity.

The National Repertoire and Standards Committee at the American Choral Directors Association began reviewing minority participation and inclusion in US choirs starting in 1979.

"In the '70s and '80s, there was a great push in diocesan choirs [across the nation] to bring in Latinos [and other multicultural groups]," said Grayson Wagstaff, dean of the school of music at Catholic University in Washington.

Wagstaff pointed out that it is important for Anglo-American Catholics not to generalize other ethnic groups and their musical traditions. He cited the example that Mexican mariachi music might not be enjoyed or appreciated in all Spanish-language Masses, where the faithful might come from a variety of countries and cultural backgrounds.

"The tapestry of our church is filled with many cultural and ethnic identities from across the spectrums of the world," said Harper. "Many voices, many languages."

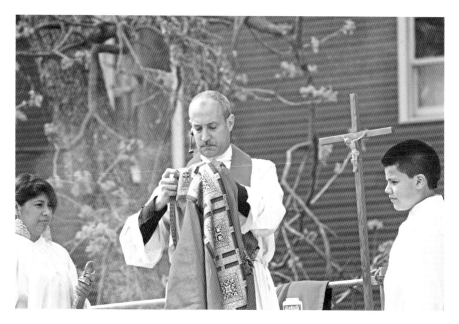

Father Shay Auerbach celebrates an outdoor Easter Mass at Sacred Heart Church in Richmond. *Christine Stoddard.*

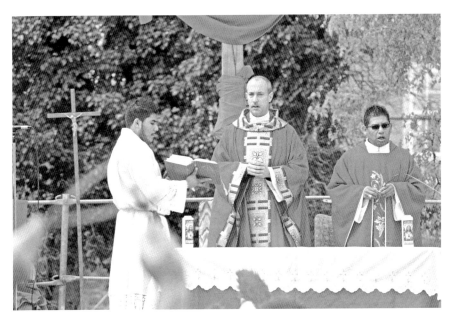

Masses at Sacred Heart Church in Richmond are often celebrated in a liturgical style befitting the parish's predominantly Mexican congregation. *Christine Stoddard.*

Father Shay Auerbach, pastor at Sacred Heart Church in Richmond, is a non-Latino priest ministering to a predominantly Latino congregation—an increasingly common US phenomenon. *Christine Stoddard.*

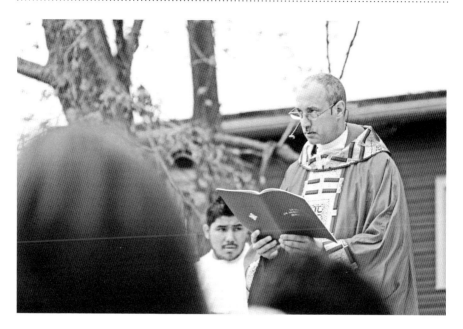

A significant portion of Father Shay Auerbach's congregation speaks Mixtec, an indigenous language. The Mixtecs have difficulty accessing language services in Richmond. *Christine Stoddard.*

Father Shay Auerbach spent time in Mexico learning the country's liturgical traditions, such as outdoor Mass, which he now carries out at his Richmond parish. *Christine Stoddard.*

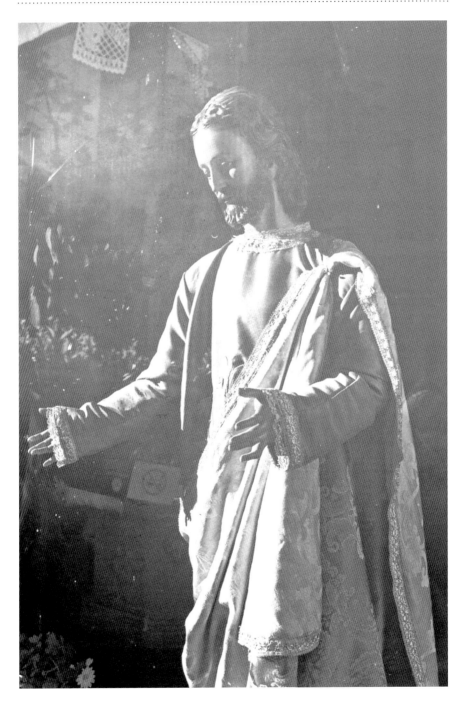

This photo depicts Jesus in a style typical to many older Latino Roman Catholic churches. *Helen Stoddard.*

## Arlington's Brazilian and Portuguese Catholics

Fifteen years ago, a small clay figurine hid in a corner by the altar at St. Anthony of Padua Church in Falls Church. Donning a long, navy veil, this little black Madonna was largely a mystery to the predominantly Latino parishioners. That's because her roots were not Mexican or Salvadoran but Brazilian.

Her name is Nossa Senhora Aparecida, Portuguese for Our Lady of Aparecida, and her story dates back to 1717 in the small city of Guaratinguetá. Legend has it that three desperate fishermen netted the statue's head instead of the hoped-for fish. Miles downriver, still unsuccessful in catching any fish, the men netted the statue's body. The two pieces fit together perfectly. After the miraculous find, the fishermen caught enough fish to feed their whole village. Today, Our Lady of Aparecida is the patron saint of Brazil, a country diverse in race and culture that has always been united by the Portuguese language.

But the Our Lady of Aparecida statue at St. Anthony was not the statue of lore. The statue was placed there by parishioner Marlene Perdigão, one of a few fervent Brazilians who advocated for an annual Portuguese-language Mass at St. Anthony. Every year for five years, the Mass was celebrated on October 12, Our Lady of Aparecida's feast day. Yet an annual Portuguese Mass was too infrequent for the Brazilians who wished to worship in their native tongue more regularly.

Neusa Maria Medeiros, a parishioner of St. Leo the Great Church in Fairfax, said that she was reminded of what was missing when her mother visited from Brazil. Unlike Medeiros, who came to the United States in 1985 to study at Mississippi State University in Starkville, her mother spoke no English. As such, she felt out of place at English Mass. This uncomfortable experience drove Medeiros to get in touch with the bishop's office.

Since then, the Office of Multicultural Ministries, headed by Corinne Monogue, has worked with the Brazilian community to make a Portuguese-language Mass possible every month. For the last ten years, the Mass has been celebrated every third Sunday of the month at Missionhurst of the Congregation of the Immaculate Heart in Arlington.

"What we learned as children is still with us," said Edson J. Barbosa, a parishioner of St. Anthony. "We need to pray in Portuguese, and we need to come together."

Though the Brazilian community lacks a priest, Barbosa has served as its unofficial leader, spending hours assembling each month's bulletin

and coordinating events. Since there are no Portuguese-speaking priests in the diocese at this time, Monogue has three on rotation from the Archdioceses of Washington and Baltimore: Father Henry Sands, Father Charles Hergenroeder and Father Sergio Dall'Agnes. Over the past decade, Monogue has scheduled more than twelve priests for the community.

Barbosa estimates that about one thousand people have attended the Portuguese Mass over the years. Two hundred of them attend somewhat consistently; at a regular Sunday Mass, there may be forty to seventy people. Typically, about one hundred people show up for the feast day of Our Lady of Aparecida, Christmas and Easter. While most of the faithful live in Northern Virginia, it is not unusual for foreign university students and Brazilian tourists passing through town to come.

"My dream is for one hundred people to come regularly to the Mass," said Barbosa. "This church was never born with the presumption of it becoming big."

So far, obtaining such numbers has been a struggle. Barbosa explained that unlike Hispanics, who often immigrate to the United States in groups, Brazilians tend to come as individuals. They come to study or pursue career opportunities, taking care to learn English and priding themselves on "melting in with American culture."

To illustrate this example, Modesto Bretas, a parishioner of St. John the Beloved Church in McLean, said, "When people ask where I am from, I say McLean. I'm not in Brazil anymore." Bretas came to the United States in 1970, living in Massachusetts until he moved to Virginia in 1988.

One of the challenges in maintaining such a small community is meeting financial obligations.

"Sometimes we don't collect enough money to pay the priest's stipend and rent the chapel," said Bretas.

Another challenge is the fact that they remain unattached to a parish. Without a parish, they cannot have a priest perform baptisms, marriages or other sacraments for their community and in their language. But in order to get a parish, explained Barbosa, they must foster a bigger community.

Don Garcia, an American who married his Brazilian wife, Teresinha, in 1969, said, "The Catholic Brazilian community will grow if we go to the communities that need us. We must go out to the ones who are lost. We must extend charity to the undocumented and the jobless, the ones who are hurting."

Garcia and his wife are parishioners of St. Ann Church in Arlington, but they attend the Portuguese Mass every month.

Despite its modest size, Monogue praises the Brazilian community for continuing to grow and looking toward the future.

"The community may be small, but it is vibrant and energetic," she said.

Arlington's Brazilian Catholic community also runs a charity named Associação Nossa Senhora Aparecida (ANSA), which translates to Our Lady of Aparecida Association, and has awarded grants for community projects in Brazil for the past thirty-three years.

"ANSA entrusts to Our Lady the inspirational task of fighting against poverty and slavery hidden under a veil of freedom," writes President Neusa Maria Medeiros in the association's October 2015 bulletin. "In the message of Aparecida, God wanted to restore the unity of our divided nation. He wanted to put an end to the sin of hunger and to restore human dignity. God needs each one of us. ANSA, through its work, wants to be an instrument of joy and to give a better quality of life to Brazilian children."

Run by an all-volunteer board of nine people, the charity raises funds through local events, online fundraisers and calls for donations at Missionhurst Chapel in Arlington, where Brazilian Mass is celebrated every third Sunday of the month at 4:00 p.m.

"[The Brazilian] community [in Washington] is not big," said Medeiros. "We know each other and we help each other spread the word about our fundraisers. We are an old organization, and we have a reputation. But we always need donations."

ANSA makes grants of up to $2,000 to nonprofit community organizations in Brazil based on proposals submitted by priests, nuns and other community leaders. All of the proposals must aim to alleviate poverty in some way and come from landowning organizations.

Throughout its history, ANSA has funded the development of a small park in Sant'Ana do Livramento, the construction of a community center in São Leopoldo, the operation of a bakery that employs mothers in need in Viamão and public health programs at a daycare center in Vila Clementino, among other endeavors.

A recent grant funded the construction of a cistern at a school in Cipó dos Anjos, allowing teachers and students to finally have access to water during the school day.

"I love all of the projects. I like to see them grow," said Medeiros. "But I think I like the cistern project best. Water is life. We cannot live without water. Imagine being at a school without water."

## Latino Response to Pope Francis

Father José Eugenio Hoyos, director of Arlington's Spanish Apostolate, attended "Called to Holiness for a New Evangelization," the third worldwide priests' retreat, on June 9–12, 2015, at the Papal Archbasilica of St. John the Lateran in Rome, where clerics from five continents reflected on the Charismatic Renewal and new evangelization. Speakers and celebrants included Pope Francis, the secretary of the Vatican State, the president of the Pontifical Council for the Laity, the president of the Pontifical Council for Justice and Peace and other Vatican officials.

Father Hoyos said that the most moving part of the conference was listening to the pope and briefly talking to him afterward.

"His talk focused on the spiritual, saying that the charismatic movement is a current of grace and [a] grand evangelization tool," he said. "He told us to treat our people well, to never fear them, to be tender and calm, that our homilies should never be boring or too long."

He said that the pope also discussed the diversity of the church, adding, "The church has many faces, but the one true face is the face of Christ in suffering."

After the pope's talk, five priests had the chance to ask what Father Hoyos described as "powerful questions" about suffering, ranging from the needs of the poor to Christian persecution.

Because he was sitting in the front row, Father Hoyos said he had the chance to approach the pope for a few minutes. He asked the pope to pray for Arlington, stressed how meaningful his trip to the United States would be and asked him to keep immigrants in his thoughts.

"In his presence, I could feel that he is a very holy man," said Father Hoyos. "It was a humbling experience. He is Jesus on earth. He made me proud to be a priest."

Father Hoyos had received his invitation to the conference three months earlier and due to the closed nature of the event traveled to Rome by himself. He kept the local Hispanic Catholic community abreast of his activities with Facebook and Twitter posts during a conference he said was "busy but very touching." Due to obligations in Arlington, he was unable to stay for the full conference.

"I enjoyed it all, but the pope had the most impact," he said.

During the World Meeting of Families from September 21 to 25, 2015, and the associated papal visit to Philadelphia on September 26–27, Latino presence and pride was clear, with Spanish-language options and respect

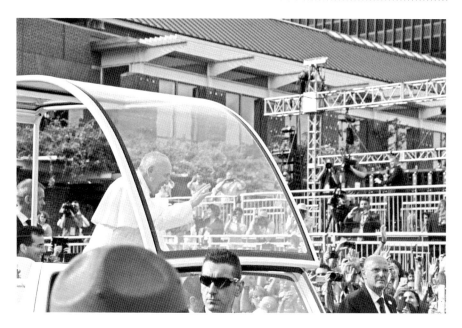

Pope Francis's 2015 visit to the United States prompted scores of Virginia's Latinos to see the pope in DC, New York and Philadelphia. *Christine Stoddard.*

paid to Latino culture throughout the week, during which the fundamental societal unit was celebrated.

On the last day of WMOF, two Spanish-language workshops were offered: one on communication for couples and the other on the importance of human dignity in immigration.

One also noticed the Latino presence during papal activities outside of the official program. Throughout Philadelphia's Center City, one could hear Spanish spoken on the streets, day and night, before, during and after presentations and workshops, while families visited the city's famous sites. On the lawn of Independence Hall and on Benjamin Franklin Parkway, as they awaited Pope Francis, people wore their homeland flags as capes, especially those from Mexico and Argentina. Many families ate empanadas and tamales during the long wait for Pope Francis to address the public. A few of the pilgrim groups, such as one representing Nicaragua, passed the time waiting in lines before the security checkpoints singing and playing instruments.

In many senses, Philadelphia's environment was friendly to Latinos, showing once again the importance of the Latin presence in the Universal Catholic Church and the United States.

## PROTESTANT AND NONDENOMINATIONAL CHURCHES

In a reaction against Catholicism, many Latin Americans have turned to Evangelical Christianity. This trend is also reflected in Latin American immigrants living in Virginia, as you will now more commonly see Protestant and nondenominational churches advertise in Spanish.

Andrew Chesnut, a professor of religious studies at Virginia Commonwealth University in Richmond, noted:

> *Interestingly in a region where historically there has been tension between Catholics and Protestants in several countries, such as Brazil, the churches have joined forces in the pro-life campaign, opposing legislation that would lift restrictions on abortion. In general, the pro-life movement isn't as organized and disciplined in Latin America as it is in the United States.*

One has to wonder how Evangelical Christianity will change Latino culture in Virginia and beyond.

# 8
# GANGS AND VIOLENCE

*At five in the afternoon.*
*It was exactly five in the afternoon.*
*A boy brought the white sheet*
*at five in the afternoon.*
*A frail of lime ready prepared*
*at five in the afternoon.*
*The rest was death, and death alone*
*at five in the afternoon.*
*—From "Lament for Ignacio Sánchez Mejías," by Federico García Lorca,*
*translated by Stephen Spender and J.L. Gili*

"Every group of humanity experiences domestic violence," said Cathy Hassinger, diocesan Catholic Charities community services director, in a 2015 interview. While there is no conclusive study showing that domestic violence occurs more commonly in any particular racial, ethnic or religious population, those who work with victims (85 percent of whom are women) face unique challenges assisting certain cultural groups. Hassinger said this includes Latinos.

One challenge, she said, is cultural. In some cultures, seeking help outside of the family or cultural group is considered shameful.

"[The victims] may want to show a good face to the community and not bring attention to negative behavior," said Hassinger. Immigrant communities may feel particular pressure to put on a good face to prevent anti-immigrant attitudes and stereotyping.

The Wayside Center for Popular Education, located outside Charlottesville, offers workshops on how to counter linguistic injustice. *Christine Stoddard.*

Another challenge is overcoming differing cultural perceptions of abuse. Domestic violence, at least certain strains of it, may be acceptable in the perpetrator's home country. Even the victim herself might think it acceptable. Though 160 countries now have legislation against domestic violence, according to UN Women, an organization focused on gender equality, enforcement of these laws is another matter.

A 2011 study from the Geneva Declaration on Armed Violence and Development cited El Salvador as the country with the highest femicide rate in the world—despite legislation to protect women. The Washington area has one of the largest Salvadoran populations in the United States, with one-third of the region's Latino population claiming El Salvador as their country of heritage. Hassinger said that some experts point to machismo, an aggressive pride for masculinity that often casts femininity as inferior, as the cultural impetus for abusing or killing female partners.

Language barriers present another hurdle in assisting victims. A victim who speaks Spanish exclusively may not know her options because shelter fliers and pamphlets are not always translated. She also may feel uncomfortable approaching an office she assumes offers only English services. But Hassinger said that in the urban and suburban areas prevalent in the Arlington

Diocese, many shelters offer in-house Spanish-language services. When in-house services are not available, shelters use three-way language lines with trained interpreters, allowing the client and social worker to communicate with each other. Community interpreters may be called on for indigenous Latin American languages such as Mixtec or Quiché.

The fear of deportation—whether of the victim or the perpetrator—poses another challenge. If the victim is undocumented, the perpetrator might intimidate her into keeping the abuse a secret by telling her he will report her to US Immigration Services if she calls the police. If the perpetrator is the undocumented one, the victim might not report him because she still loves him or relies on him for financial support.

Hassinger believes that fear of deportation accounted for a drop in the number of Latina clients at Bethany House, a Christian women's shelter in Fairfax, during her tenure as executive director. Prior to Prince William County tightening its immigration laws in 2007, about 30 percent of Bethany House clients were Latina. After the reform, Hassinger said the number fell to about 12 percent.

"There's no way you could say that it was because the culture had an extreme change of heart," said Hassinger.

Hassinger said that the Violence Against Women Act (VAWA) is in place to protect victims from deportation. Under the VAWA, the victim may be afforded special routes to legal immigration status if she is married to her perpetrator. By completing the VAWA petition, officially known as Form I-360 Self-Petition, the victim may apply for immigration status for herself and her children without her husband's knowledge.

In order to qualify, the victim must have experienced the abuse while married and living in the United States with the perpetrator. The petitioning process also requires submitting evidence of abuse and often involves a review of the victim's criminal record, as well. In the Arlington Diocese, victims may seek assistance with the VAWA petition from the legal office of Catholic Charities Hogar Immigrant Services.

Regardless of a victim's racial, ethnic or cultural background, it can be difficult for her to leave her abuser, said Hassinger.

"She may continue to feel affection and love for the abuser and just wants the abuse to stop," she said. Separating from the perpetrator often requires making drastic financial sacrifices, especially if he is the primary earner. Leaving him can mean choosing homelessness and food insecurity and possibly death. Hassinger added that 50 to 70 percent of domestic violence–related murders occur after the victim leaves home.

Southside Richmond is one of several historically low-income black areas that Latinos gradually are dominating. *Christine Stoddard.*

Sacred Heart Catholic Church is an anchor of the high-poverty Blackwell community in Southside Richmond. *Christine Stoddard.*

"My experience working with these women is that they are very strong," she said. "It is challenging to rebuild after abuse. We have to recognize their resilience."

Belonging to a gang makes it more difficult for a Latina to escape her abuser and start a new life. In 2005, there were an estimated 2,000 gang members in the Washington, DC area. Today, there are more than 3,500.

MS-13, a gang founded by Salvadoran immigrants in Los Angeles during the chaos of El Salvador's civil war, has a strong presence in Northern Virginia. Or, to use the words of a 2013 Watchdog Wire headline, Virginia has turned into a stronghold for the hyper-violent MS-13. Worldwide, MS-13 is estimated to have anywhere from ten thousand to seventy thousand members, with most members being Central American or of Central American descent. Outside of the Washington, DC area, particularly in Los Angeles, the 18th Street Gang is MS-13's major rival. However, that is not the case in Northern Virginia. South Side Locos, a newer gang founded by an ex-MS-13 member and affiliated with the Sureños, is the second-largest Latino gang in Northern Virginia.

The prevalence of Latino gangs in Northern Virginia garnered national attention in the early 2000s. The killing of eighteen-year-old Brenda Paz—a Honduran-born MS member known as "Smiley"—in 2003 was perhaps the catalyst for the media sensation. She was found dead, seventeen weeks pregnant, in the Shenandoah River, three weeks after leaving the Witness Protection Plan. Paz, the former girlfriend of notorious MS member Denis Rivera, had been stabbed to death. In 2001, Rivera was sentenced to life in prison for the slaying of Joaquim Diaz on Daingerfield Island, north of Old Town Alexandria. Paz was scheduled to testify in that trial shortly before she was killed, having earned the reputation as a "snitch."

Vandalism and graffiti make up the majority of reported gang activity. When "MS-13" was spray-painted on a tree in Sterling's Coventry Square in early 2006, a turf war broke out between MS-13 and 18th Street Gang members that summer. An innocent forty-seven-year-old man who was sleeping toward the front of his town house was killed when guns were fired at seven homes. But not all vandalism and graffiti in Nothern Virginia has such a sinister connection.

On December 20, 2010, a user with the screen name Tiger Beer wrote, "Do you see MS-13 graffiti in NoVa?" on City-Data.com, a forum about life in cities and regions across the country. By December 30, there were more than six pages' worth of posts in response. The conclusion? Most of it is kids' play.

One belief is that many Latino gang members are in the United States illegally and come here specifically to do crime. Take this comment from

John Rice in the March 2010 *Loudoun Times* story "MS-13 Member's Trial Shows Gang's Movement": "It is unfortunate that there are individuals who continue to see illegals as hard-working, hapless folks just trying to give their families better lives." Or from ponygirl: "I don't think there is a solution to the myriad problems attached to illegal immigrants, but I'm very, very grateful to and proud of the NoVa Regional Gang Task Force as well as our own Sheriff Simpson and the Loudoun County Sheriff's Deputies for their vigilance." Or from deb: "There seems to be a lack of understanding by those who are here ILLEGALLY that they start life off here by breaking the law...and it goes from there..."

It seems more likely, however, that the pattern is that certain undocumented Latinos come to the United States when they are young and, for various reasons, feel out of place. They join a gang to foster their identity and a sense of family.

In 2003, the Northern Virginia Regional Gang Task Force was established as part of the Department of Justice Appropriations Bill, with the support of Frank R. Wolf of Virginia's Tenth Congressional District. The task force includes the participation of Arlington County, the City of Alexandria, the Town of Dumfries, the City of Fairfax, Fairfax County, the City of Falls Church, Fauquier County, the Town of Herndon, the Town of Leesburg, Loudoun County, Manassas City, Manassas Park, Prince William County, the Town of Vienna, the Town of Warrenton and the Virginia State Police. It covers a total of 1,300 square miles.

From 2004 to 2005, the task force stated that reports of serious gang crimes dropped by 39 percent.

According to the task force's Northern Virginia Comprehensive Gang Assessment (2003–2008), these five regional characteristics allow Latino gangs to flourish: sustained population growth, population turnover, massive immigration, demographic inversion and the regional economy. Population growth means more young people in the region, prime time for joining a gang; population mobility means that it is hard to track gang members, who, like many people in the region, are constantly moving; immigration is more complex; demographic inversion means minority population becoming the majority; and a vibrant economy means opportunities are plentiful. There is an average of 1,700 gang-related crimes reported a year, but it is hard to determine which crimes are gang related and which aren't. There were 5,200 reported graffiti cases over the course of the six years the assessment took place. The task force arrested 952 gang members from July 2003 through the end of 2008. Together, the jurisdictions maintain a resource information line at 703-GET-HELP. They also cooperate to produce brochures, videos

and radio PSA in English and Spanish. All of these materials are available online at PreventGangsNoVa.org.

Gangs threaten a community in many ways, but a topic of more recent concern in Virginia is the issue of human trafficking. Though selling humans is not new in Virginia—Richmond, after all, was a major hub in the Atlantic slave trade during the colonial era—the advent of Latino gangs has changed the nature of the crime. In Virginia, the MS-13 has been strongly associated with human trafficking.

"Human trafficking doesn't just happen in Latin America or Asia," said Carolina Velez. "It happens here, too, even in Virginia. Right in Richmond. Every day."

It was a mild Saturday morning in January 2013, and Velez was spending her free time as she often does: advocating. Velez was one of two guest speakers delivering a lecture on prostitution aboard the Virginia Center for Latin American Art's converted school bus. While the audience members clutched their Lamplighter coffees in the intimate space, Velez illustrated her carefully researched statistics with her own testament. She told the story of a local teenage girl who had been lured into selling her body.

This girl, who was one of Velez's many clients while she worked as a social worker at Safe Harbor Shelter, was about sixteen years old on the day she was walking home from school and her fate was forever changed. A mother and son drove up to the girl and offered her a ride home. The girl accepted. The mother and son began meeting the girl at her home, taking her out and giving her the emotional support and material objects that her parents did not. The son even took her as his girlfriend. Shortly thereafter, the mother and son convinced the girl to sell her body under their management. And so her career as a prostitute began.

Such a case is simply one of myriad that Velez has come to know since she moved to Richmond from Colombia in 2001. Velez explained that because of its relatively low population density, sprawling nature and location off Interstate 95, Southside Richmond is one of the East Coast's human trafficking hot spots. Now Velez recognizes "street-walkers" at a glance.

Since arriving in Richmond, Velez has faced many challenges defining herself within mainstream American culture, prompting her to passionately serve Richmond's Hispanics. She especially strives to help those who, unlike her, lack education and a command of the English language.

"What I did not know [before moving to Richmond] was that I was going to become 'Latina,'" Velez wrote in an e-mail, "that my people were no longer only Colombians, that I was part of a bigger world."

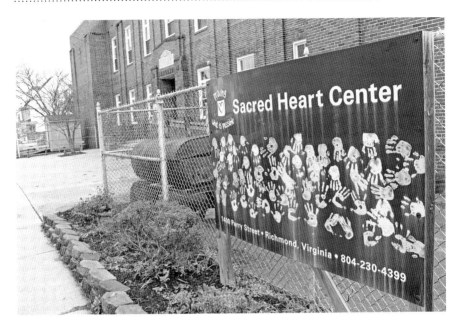

Sacred Heart Center assists many new Latino immigrants in Southside Richmond with English classes, paperwork, social activities and more. *Christine Stoddard.*

Many of Richmond's new Latino immigrants live in trailer parks on or near Jefferson Davis Highway. *Christine Stoddard.*

As a Safe Harbor social worker, Velez provides counseling and Spanish-language support to immigrant women (and occasionally men) who wish to discuss their experiences with sexual violence. While some of these women have suffered abuse by a partner or relative at home, others have been forced into sex work. Many were originally promised jobs as nannies or maids in their native countries and then brought to the United States to become prostitutes. Others were coerced after having already established lives in Richmond. Today, Velez continues her community work as an independent consultant.

Outside of Safe Harbor, Velez volunteers with the local Mixteco Indian community and for the Wayside Center for Popular Education in Charlottesville. Velez brings her commitment to social justice and sense of duty toward struggling Latin American immigrants to both of these volunteer roles. But there's another role that Velez also plays.

"One of my favorite roles is being a mom," Velez said. "And I feel very grateful because life gave me an amazing daughter. Being a better me is something that I will continue doing in order to offer my daughter what she needs to continue being the amazing human being she is."

Velez hopes to continue working with survivors of domestic and sexual violence and bring more awareness to the issue of sexual violence.

"My constant struggle is to have balance in life, between my personal life, work life and activism life."

# THE FUTURE OF HISPANICS AND LATINOS IN VIRGINIA

*Whatever one believes, distance in human culture is not a factor of space, but rather of time; the distance to a place is really how long it takes to get there.*
—Ancient Mexico: An Overview, *by Jaime Litvak King*

Today's Virginia is not the same place that it was for Hispanics and Latinos during my childhood. Today, it is a place of growth, progress and hope. The sun has risen on a time of possibility and change for a fast-growing legacy of a vibrant and diverse group of people.

Arlington's Crystal City neighborhood is seeing a quick shift in its demographics, with more high-end housing and entertainment options attracting college-educated Latino professionals. *Christine Stoddard.*

Herndon has one of the fastest-growing Latino immigrant populations in the state, which is a trend likely to continue. *Christine Stoddard.*

Despite its natural beauty, the Northern Neck's high poverty rate and sparse community resources make it a difficult place for new Latino immigrants to live. *Christine Stoddard.*

Whether they hail from Spain or Brazil, Hispanics and Latinos are playing a bigger role in Virginia's story. Change is on the horizon. *Helen Stoddard.*

According to the Pew Research Center, Virginia's Hispanic and Latino population will outnumber the non-Hispanic/Latino population by 2050. In 2011 alone, about forty-four thousand Central American immigrants obtained their green cards. That same year, an estimated 14 percent of undocumented immigrants living in the United States are believed to have come from El Salvador, Guatemala and Honduras. Hispanic and Latino population growth is anticipated for the entire United States. As this happens, mixed households—that is, ones with one Hispanic or Latino parent and one non-Hispanic/Latino parent—will become increasingly common.

As more Hispanics and Latinos come to Virginia, their influence over the state's culture and economy surely will usher in a new era for the commonwealth.

# BIBLIOGRAPHY

Anger, Matthew M. "Spanish Martyrs for Virginia." Seattle Catholic. http://www.seattlecatholic.com/article_20030830.html (accessed August 2003).

Brogan, T.V.F. *The Princeton Handbook of Multicultural Poetries.* Princeton, NJ: Princeton University Press, 1996.

Brown, Steven Ford. "At a Crossroads: Poetry from the New Spain." *Atlanta Review* (Spring/Summer 2003).

Burch, Brian, and Emily Stimpson. *The American Catholic Almanac: A Daily Reader of Patriots, Saints, Rogues, and Ordinary People Who Changed the United States.* New York: Crown Publishing Group, 2014.

"Do You See MS-13 Graffiti in NoVA? (Fairfax: Neighborhood, Zoning)." City-Data Forum. http://www.city-data.com/forum/northern-virginia/1156850-do-you-see-ms-13-graffiti.html (accessed December 21, 2010).

Elliott, J.H. "The Iberian Atlantic and Virginia." In *The Atlantic World and Virginia, 1550–1624*, edited by Peter C. Mancall. Chapel Hill: University of North Carolina Press, 2007.

"Fact Sheet: Understanding the Latino Culture." Ohio State University Extension, Family and Consumer Sciences, 2009. http://ohioline.osu.edu/hyg-fact/5000/pdf/5237.pdf.

*Fairfax Times.* "MS-13 Gang Members Sentenced to Prison on Sex Trafficking Charges." http://fairfaxnews.com/2013/03/ms-13-gang-members-sentenced-to-prison-on-sex-trafficking-charges (accessed March 4, 2013).

Gibson, Dave. "Virginia Has Turned into Stronghold for Hyper-Violent MS-13." Watchdog Wire. http://watchdogwire.com/blog/2013/05/21/virginia-has-turned-into-stronghold-for-hyper-violent-ms-13 (accessed May 21, 2013).

Glod, Maria, and Ian Shapira. "Fairfax Teen Is Charged in Machete Wounding." *Washington Post.* http://www.washingtonpost.com/wp-dyn/articles/A25462-2004May13.html (accessed May 14, 2004).

Gonzalez, Erika, and Mila Mimica. "Exploring a Notorious Gang's Ties to Virginia." NBC 4 Washington. http://www.nbcwashington.com/news/local/Inside-a-Notorious-Gangs-Ties-to-Virginia-226839301.html (accessed October 8, 2013).

Guillen, Sandy Mckinney. "Spain: Poetry from the Castilian, Catalan, Basque and Galician Languages." *Atlanta Review* (Spring/Summer 2003).

"Hispanic Prisoners in the United States." The Sentencing Project, 2003. http://www.sentencingproject.org/doc/publications/inc_hispanicprisoners.pdf.

"Hispanics and Latinos in Virginia." Richmond: Virginia Is for Lovers, Official Tourism Website of the Commonwealth of Virginia, 2015. http://www.virginia.org/HispanicsandLatinosinVirginia.

"Human Trafficking." United Nations Office on Drugs and Crime, 2015. http://www.unodc.org/unodc/en/human-trafficking/what-is-human-trafficking.html.

Jackman, Tom. "Task Force Tackling Gangs from All Angles." *Washington Post.* http://www.washingtonpost.com/wp-dyn/content/article/2006/07/19/AR2006071901935.html (accessed July 20, 2006).

Kashino, Marisa. "You're Pretty—You Could Make Some Money." *Washingtonian.* http://www.washingtonian.com/articles/people/youre-pretty-you-could-make-some-money (accessed June 10, 2013).

Knox, George W. "Females and Gangs: Sexual Violence, Prostitution, and Exploitation." National Gang Crime Research Center, 2008. http://www.ngcrc.com/ngcrc/proffem2.htm.

"Latinos in Our Area." Creciendo Juntos—Growing Together. http://cj-network.org/cjlatarea/latinos_va.html.

Lawall, Sarah. *The Norton Anthology of World Masterpieces: The Western Tradition.* 7th ed., vol. 2. New York: W.W. Norton & Company, 1999.

"Los Tatuajes en las Maras, un Submundo Tenebroso." *El Heraldo.* http://www.elheraldo.hn/sucesos/743447-219/los-tatuajes-en-las-maras-un-submundo-tenebroso (accessed August 31, 2014).

*Loudoun Times-Mirror.* "Gov. McAuliffe Outlines $109 Billion Budget Proposal." http://www.loudountimes.com/index.php/news/article/ms-13_members_trail_shows_gangs_movement (accessed December 18, 2015).

"Northern Virginia Comprehensive Gang Assessment: 2003–2008." Northern Virginia Regional Gang Task Force. http://www.preventgangsnova.org/NoVaGangAssessmentSept212009.pdf (accessed September 21, 2009).

Rivera, Elaine. "Man Receives 20 Years in Gang Attack at Va. Party." *Washington Post.* http://www.washingtonpost.com/wp-dyn/articles/A17129-2004Jun4.html (accessed June 5, 2004).

Rondeaux, Candace. "Gunfire Hits Even Loudoun Homes." *Washington Post.* http://www.washingtonpost.com/wp-dyn/content/article/2006/07/19/AR2006071900361.html (accessed July 20, 2006).

Scott, Katie. "A Call to Fight Human Trafficking." *Arlington Catholic Herald.* http://catholicherald.com/stories/A-call-to-fight-human-trafficking,27554 (accessed November 12, 2014).

Sheridan, Mary Beth. "In N. Va. Gang, a Brutal Sense of Belonging." *Washington Post.* http://www.washingtonpost.com/wp-dyn/articles/A10440-2004Jun27.html (accessed June 28, 2004).

Stockwell, Jamie. "In MS-13, a Culture of Brutality and Begging." *Washington Post.* http://www.washingtonpost.com/wp-dyn/content/article/2005/05/01/AR2005050100814.html (accessed May 5, 2005).

Thornton, Richard. *Earthfast, the Dawn of a New World: 1526–1610*. N.p.: Lulu Publishing, n.d.

Zapotosky, Matt. "Gangs in Northern Virginia Increasingly Selling Children for Sex." *Washington Post*. http://www.washingtonpost.com/local/gangs-in-northern-virginia-increasingly-selling-children-for-sex/2013/09/29/3386e1a8-1c9c-11e3-82ef-a059e54c49d0_story.html (accessed September 29, 2013).

Zong, Jie, and Jeanne Batalova. "Central American Immigrants in the United States." Migration Policy Institute. http://www.migrationpolicy.org/article/central-american-immigrants-united-states (accessed September 2, 2015).

# WEBSITES

http://catholicherald.com/stories/Arlington-Diocesan-teachers-provide-English-Language-Learners-with-special-support,28118?content_source=&category_id=&search_filter=&event_mode=&event_ts_from=&list_&order_by=&order_sort=&content_&sub_&town_id=.

http://catholicherald.com/stories/Brazilian-Catholic-charity-alleviates-poverty,30180.

http://catholicherald.com/stories/Central-American-parents-petition-to-be-reunited-with-their-children,29425.

http://catholicherald.com/stories/City-of-Brotherly-Love-welcomes-Pope-Francis,29984?content_source=&category_id=&search_filter=city+of+broth erly+love+pope+francis&event_mode=&event_ts_from=&list_type=&order_by=&order_sort=&content_class=&sub_type=stories,blogs&town_id=.

http://catholicherald.com/stories/Consecrated-layman-guides-Hispanic-youth-at-Stabat-Mater,30879.

http://catholicherald.com/stories/Corinne-Monogues-powerful-adoption-story,28296?content_source=&category_id=&search_filter=corinne+monogue&event_mode=&event_ts_from=&list_&order_by=&order_sort=&content_&sub_,blogs&town_id=.

http://catholicherald.com/stories/Diocesan-Multicultural-Choral-Concert-to-celebrate-diversity-of-faith,28769.

http://catholicherald.com/stories/Domestic-violence-among-Latinos,30142.

http://catholicherald.com/stories/Faith-undeterred-by-distance,27550?content_source=&category_id=&search_filter=christine+stoddard&event_mode=&event_ts_from=&list_&order_by=&order_sort=&content_&sub_,blogs&town_id=.

http://catholicherald.com/stories/Faithful-social-worker-wins-national-award,28967?content_source=&category_id=&search_filter=ana+bonilla&event_mode=&event_ts_from=&list_&order_by=&order_sort=&content_&sub_,blogs&town_id=.

http://catholicherald.com/stories/Family-shows-with-Latin-Flavor,27436?content_source=&category_id=&search_filter=christine+stoddard&event_mode=&event_ts_from=&list_&order_by=&order_sort=&content_&sub_,blogs&town_id=.

http://catholicherald.com/stories/Focusing-quinceaeras-on-faith,28373?content_source=&category_id=&search_filter=Focusing+quinceañeras+on

+faith+&event_mode=&event_ts_from=&list_&order_by=&order_
    sort=&content_&sub_,blogs&town_id=.

http://catholicherald.com/stories/Fr-Hoyos-spends-a-few-minutes-with-the-
    pope,29250.

http://catholicherald.com/stories/Hispanic-communities-celebrate-Three-Kings-
    Day,27954.

http://catholicherald.com/stories/La-Virgen,27823?content_source=&category_
    id=&search_filter=christine+stoddard&event_mode=&event_ts_from=&list_&order_
    by=&order_sort=&content_&sub_,blogs&town_id=.

http://catholicherald.com/stories/Los-latinos-se-alegran-al-ver-al-papa,29988?content_
    source=&category_id=&search_filter=latinos+se+alegran&event_mode=&event_
    ts_from=&list_type=&order_by=&order_sort=&content_class=&sub_
    type=stories,blogs&town_id=.

http://catholicherald.com/stories/New-diocesan-initiative-aims-to-increase-
    Hispanic-student-enrollment,28863?content_source=&category_id=&search_
    filter=venga&event_mode=&event_ts_from=&list_&order_by=&order_
    sort=&content_&sub_,blogs&town_id=.

http://catholicherald.com/stories/Salvadoran-community-should-feel-proud-of-
    Archbishop-Romeros-beatification,29002?content_source=&category_id=&search_
    filter=romero&event_mode=&event_ts_from=&list_type=&order_by=&order_
    sort=&content_class=&sub_type=stories,blogs&town_id=.

http://catholicherald.com/stories/The-crisis-in-Hispanic-vocations,27478.

http://catholicherald.com/stories/The-gift-of-motherhood,27866?content_
    source=&category_id=&search_filter=christine+stoddard&event_mode=&event_
    ts_from=&list_&order_by=&order_sort=&content_&sub_,blogs&town_id=.

http://catholicherald.com/stories/The-joy-of-picnicking-in cemeteries,27438?content_
    source=&category_id=&search_filter=christine+stoddard&event_mode=&event_ts_
    from=&list_&order_by=&order_sort=&content_&sub_,blogs&town_id=.

http://ecs.force.com/mbdata/mbstcprofexc?Rep=ELP14&st=Virginia.

http://virginiaindians.pwnet.org/history/paleo.php.

http://www.catholicnews.com/data/stories/cns/1302111.htm.

http://www.dhr.virginia.gov/arch_NET/timeline/time_line.htm.

http://www.henricomonthly.com/news/global-education.

http://www.migrationpolicy.org/article/salvadoran-immigrants-united-states.

http://www.migrationpolicy.org/data/state-profiles/state/demographics/VA.

http://www.pewresearch.org/fact-tank/2014/09/16/11-facts-for-national-hispanic-
    heritage-month.

http://www.virginiaplaces.org/settleland/spanish.html Charles A. Grymes, George
    Mason University.

https://wamu.org/news/15/08/17/dcs_salvadoran_foodies_elevating_their_
    countries_tasty_fare.

# INDEX

# ABOUT THE AUTHOR

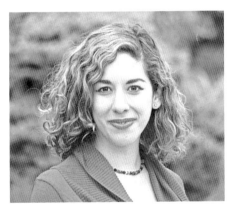

Christine Stoddard is a writer, artist and AmeriCorps alumna originally from Arlington, Virginia. In 2014, *Folio* magazine named her one of the country's top twenty media visionaries in their twenties for founding *Quail Bell* magazine and other projects under the Quail Bell Press & Productions umbrella. Christine's work has appeared in *Cosmopolitan*, *Tulane Review*, the New York Transit Museum and beyond. Her endeavors have been recognized by Time Out New York, BinderCon NYC, the *Washington Post Express*, *Style Weekly*, the Puffin Foundation, the Newseum Institute and other organizations. Previously, she co-authored the Arcadia Publishing title *Images of America: Richmond Cemeteries*.